The BARRIER ISLANDS

The

BARRIER ISLANDS

*A Photographic History of Life on
Hog, Cobb, Smith, Cedar,
Parramore, Metompkin,
& Assateague*

*by Curtis J. Badger
and Rick Kellam*

Stackpole Books

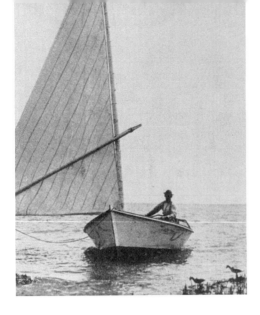

Published by
STACKPOLE BOOKS
Cameron and Kelker Streets
P.O. Box 1831
Harrisburg, PA 17105

Printed in the United States of America

10 9 8 7 6 5 4 3 2 1

Library of Congress Cataloging-in-Publication Data

Badger, Curtis J.
 The Barrier Islands.

 1. Barrier islands—Virginia—Pictorial works.
 2. Virginia—Description and travel—1981– —Views.
 3. Virginia—Social life and customs—Pictorial works.
 I. Kellam, Rick. II. Title.
 F227.B33 1989 975.5'15 88-24826
 ISBN 0-8117-0213-8

To John S. and Ella Mae Melvin
of the community of Broadwater, and to all
the others whose lives on the
Virginia barrier islands define our past,
and enlighten our future.

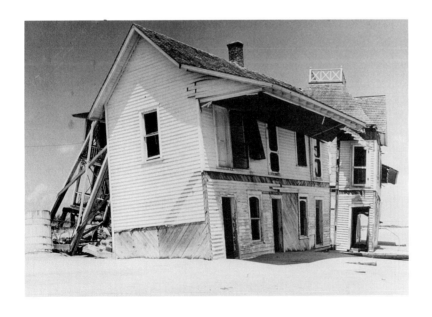

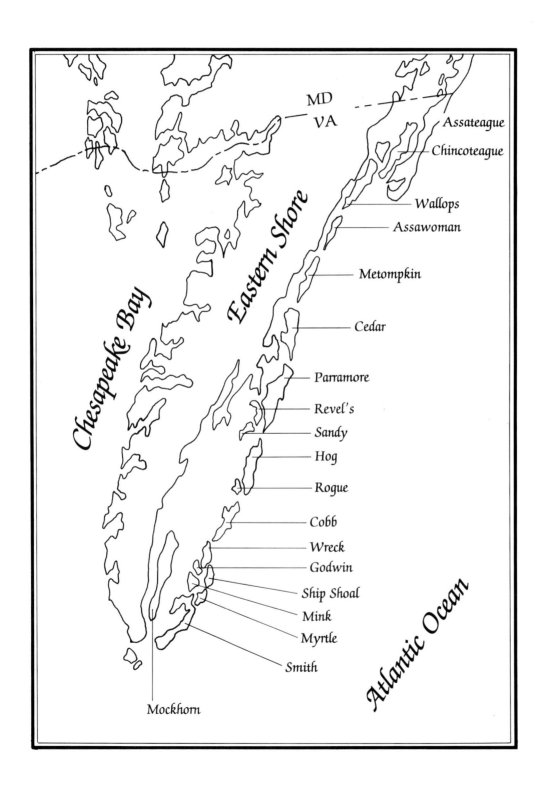

MD
VA

Assateague

Chincoteague

Wallops

Assawoman

Metompkin

Cedar

Parramore

Revel's

Sandy

Hog

Rogue

Cobb

Wreck

Godwin

Ship Shoal

Mink

Myrtle

Smith

Mockhorn

Chesapeake Bay

Eastern Shore

Atlantic Ocean

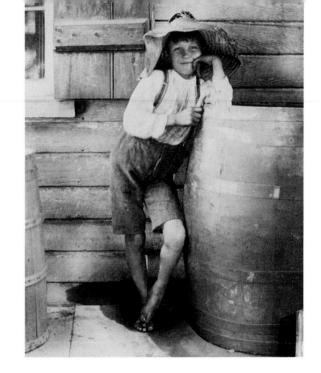

Table of Contents

Acknowledgments

A book such as this would not be possible without the assistance of many people, especially those who graciously lent us photographs. We are very grateful to the public institutions that opened their files to us, and we want to salute the many residents of the Eastern Shore who allowed us to thumb through their photo albums and to copy many interesting old pictures.

Within the past century, life on the Virginia barrier islands has changed dramatically. Villages such as Broadwater, which once was a thriving community, are now only memories and the only knowledge the younger generations will have of such places is what is passed on through the written word or in photographs such as these.

This book, then, is done to pay tribute to the generations that came before, and also to provide future generations with a clear and poignant understanding of their roots. We thank all of you who have helped with this project.

The following people provided photographs and information on various aspects of barrier island life: Mrs. Mary Doughty, Mrs. Eunice Glaxner, Pete Peterson, Thelma Peterson, Wendell Bowen, Mae Bowen, Yvonne Widgon, Marion Marshall, Randy Lewis, Florence Lawson, Grafton Bowen, Lorraine Birch, Margaret Rayfield, Mr. and Mrs. Jim Taylor, Ed White, Maywood Boole, Bob Bowen, Larry Matthews, Ronnie Kellam, Ted Ward, Ed Beyersdorfer, Mr. and Mrs. Tom Parsons, Grayson Chesser, James A. Kelly, John Maddox, and Buddy Bell. Thanks also to these institutions: The Nature Conservancy, The Eastern Shore Public Library, The Eastern Shore News, The National Archives, The Smithsonian Institution, The Ward Foundation, and The National Geographic Society.

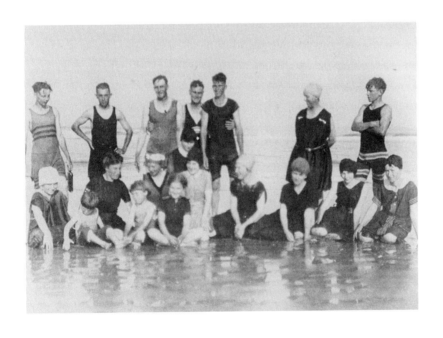

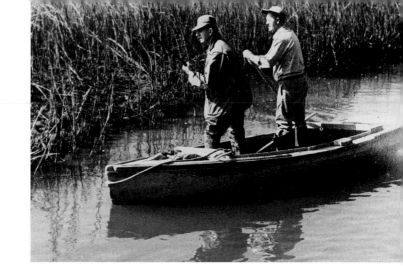

Foreword

Virginia's coastal islands make up the last such undeveloped barrier system on the Atlantic coast. The islands stretch for some seventy miles along the coast of the Eastern Shore, from Assateague at the Virginia–Maryland state line southward to Smith and Fisherman Islands in Northampton County.

The islands today are much as they have been for centuries. They are remote, wild, and beautiful places where one can stand on the berm of the beach and gaze for miles in all directions without seeing another person. The islands and their leeward marshes are important breeding grounds for nesting birds, and their estuaries provide safe harbor for thousands of migrating waterfowl each winter.

Along the populous Atlantic coast, where most of the barrier islands and marshes have been filled and paved and covered with tourist attractions, these islands alone represent a barrier system as nature intended it. Virginia's barrier islands are a national treasure, a wilderness system just as vital and awe-inspiring as the mountains and canyons of the West.

Most of the islands today are owned by The Nature Conservancy, the Arlington, Virginia, land preservation group, and are part of the Virginia Coast Reserve, a 40,000-acre sanctuary consisting of barrier beaches, saltmarshes, and a few adjacent mainland farms. Other islands, such as Assateague and Fisherman, are part of the national wildlife refuge system, and three smaller islands are owned by the state and are managed as wildlife areas.

Because of their isolation, the Virginia islands were spared the drastic brand of development that has occurred this century along the New York, New Jersey, Delaware,

Maryland, and North Carolina coasts. And now there is a growing awareness that the islands are important because they are undeveloped; they are the final survivors of an endangered breed.

This is not to say that these islands have never had their flings with human habitation. This book, in fact, is a visual record of the relationship between the islands and man, and it is intended to show how the islands and saltmarshes shaped the history and culture of Virginia's Eastern Shore.

Ironically, fewer people live on the islands now than at any time during their recorded history. First there were the Indians, tribes such as the Assateagues of the Nanticoke nation. Then there were early settlers, saltmakers, farmers, fishermen, and sundry others who preferred the freedom of island life to the structure of mainland towns. At various times there were small villages on many of the islands, the most noted of which were at Assateague, Hog, and Cobb Islands. During the early part of this century, more than 200 persons lived in the village of Broadwater on Hog Island. And on Cobb Island during the years following the Civil War, the Cobb family ran a hotel that attracted the wealthy and famous from all over the country.

When people lived on the islands, it was always on the islands' terms, and at the islands' pleasure. Most of the island residents depended upon the productive marshes and bays for their livelihoods. They fished during the summer, dug clams, collected oysters and crabs, and shot waterfowl and shorebirds for market. Although the fish and game were plentiful, island life could be harsh and unforgiving. People were directly dependent upon the gifts of nature for survival, and in villages such as Broadwater the islanders concluded the final act of Virginia's colonial tradition, their lives intimately woven into the fabric and bounty of the land.

For centuries people used the islands, leaving few indelible marks. Unlike the spirit of the frontier West, and unlike that of modern developers, there was no inclination to conquer the islands, to tame the tides and shifting sands, to transform a tenuous barrier island into something rigid and permanent. Over the centuries the islanders learned that eventually nature will have its way. When an encroaching ocean threatened Hog Island in the late 1920s and 1930s, the islanders did not petition the state for jetties and beach replenishment projects. They jacked up their homes, school, and church, loaded them onto barges, and moved them to the mainland. The dissolution of the village came with sadness, but also with a certain stoic resignation that certain events of nature are beyond human control.

The photographs in this book celebrate man as a participant in nature, as a vital cog in the natural scheme of things. Of course, man has taken a great deal more from the islands and marshes than he has given back, but perhaps by remembering these special people and special places, we will learn something of value, something that will nurture future generations of Eastern Shore residents.

COBB ISLAND

Nathan Cobb and the
Sporting Life

Cobb is a sandy finger of an island, a narrow strip of beach, cordgrass, and marsh elder that fronts the Atlantic Ocean for six miles along Virginia's Eastern Shore. As islands go, Cobb is an unpretentious place. It is flat and open with very little high ground and none of the ancient pine forests that grace higher islands such as Parramore and Assateague. The beach is smooth, with a gentle berm that drops slowly toward the ocean. On its small dunes grow thickets of twisted elder and dwarf cedars whose limbs have been wrenched by Atlantic storms. On the leeward side of the island is Easter Marsh and the Intracoastal Waterway, the inland passage that is protected from the ravages of the ocean by these barrier islands.

Cobb Island is a wonderful wild place, preserved in its natural glory by The Nature Conservancy, the Arlington, Virginia, land preservation organization that created the 40,000-acre Virginia Coast Reserve in the 1970s. The only imprints of civilization on Cobb Island today are the flotsam from passing ships and the two derelict lifesaving stations that stand like huge gray ghosts on the island's southern tip.

It's difficult to imagine that just over a century ago this modest little island was a gathering place for the rich and famous, a retreat for the business and government leaders who healed America's wounds following almost five years of divisive civil warfare.

Just as it is today, in the early 1800s the island was a peaceful, uninhabited little barrier beach. Then a Cape Cod shipbuilder named Nathan Cobb came along, and for a brief moment he turned the island into something vital and important. The Cobbs have gone, but they left an indelible mark on the history and culture of these seaside barrier islands.

Cobb's family had for generations been in the shipbuilding and freighting business on Cape Cod, but in 1833, when Cobb was thirty-six years old, his wife Nancy became ill with tuberculosis. Doctors prescribed a warmer climate, so the Cobbs and their three young sons loaded their belongings onto a schooner and set sail.

Accounts vary as to how and why the Cobbs settled on the Eastern Shore of Virginia. Richard L. Parks, writing in his 1947 book, *Duck Shooting Along the Atlantic Tidewater*, speculates that Cobb had earlier visited Northampton County while shipping potatoes along the coast and had become enamoured of the fertile soil and abundant wildfowl. This account makes sense. Cobb was a shrewd, practical New England business-man, and it is doubtful he would have set out with no definite destination or plan. And he probably had visited the Eastern Shore on shipping business. (When the whaling industry slumped, the Cobbs turned increasingly to shipping.)

The Cobb family settled near the village of Oyster, where they ran a small store for several years. In his late thirties, Cobb was still a vigorous man, and he soon became bored with the confining life of a shopkeeper. So he and several acquaintances established a ship salvage business, which apparently did very well.

Sand Shoal Island lay off the coast of Northampton County, and Cobb had visited it numerous times to salvage schooners that had grounded on the broad sandbars. The island had been granted to Andrew Fabin and William Satchel by the provincial governor of Virginia in 1734, and it had been in the Fabin family since. At the time, the island was owned by one William "Hardtime" Fitchett, a descendant of the Fabins. Cobb purchased the island from Fitchett in March 1839—reportedly for 100 bags of salt that Cobb had boiled out on Fitchett's own island—and he, Nancy, and the three boys dismantled their home near Oyster and moved it to Sand Shoal Island, which was immediately renamed Cobb Island.

Nancy died within a year of the move to the island, and she was buried in a cemetery near the family home. Nathan soon remarried, and the three sons—Nathan, Jr., Warren, and Albert—also brought brides to the island. They lived a rather idyllic, but clannish, life. The local waters teemed with oysters, clams, and crabs. From April until November the fishing was excellent in the surrounding bays and in the island surf. The island was on a major waterfowl flyway, and each fall the family would shoot hundreds of ducks for markets in Baltimore and New York. So, between the salvage business and fishing and hunting for the market, the family prospered.

When the country began a return to normalcy after the Civil War, there came a need for diversion, for recreation. Cobb Island, because of the family's involve-ment in market gunning, had already gained a reputation for its great flights of waterfowl and shorebirds, and the Cobbs began taking out parties, usually well-to-do northern businessmen seeking to escape the drudgery of industry for a few weeks.

As the guiding business increased, the Cobbs began devoting more of their energies to it. Acting as hunting and fishing guides for bankers and politicians was

certainly easier and safer than pulling ships from the island shoals, and the Cobbs found that it could be quite lucrative. But what they really needed was a hotel, a building in which they could entertain dozens of visitors at one time.

Like a gift from Providence, the coffee barque *Bar Cricket*, sailing from Rio de Janeiro, grounded on shoals almost directly in front of the Cobbs' house. The Cobbs salvaged the vessel, its crew, and its cargo, and after a lengthy legal dispute, they were awarded $18,000. The hotel was quickly under way.

The Cobbs built a rambling, white frame structure that was expanded over the years as the business grew. Quarters for hotel staff were added, and homes were built for the growing family. Each of the three sons had sons of their own: Elkanah was born to Nathan, Jr.; Arthur to Warren; and Lucius to Albert. In time, these young men, the grandsons of the patriarch Nathan, Sr., had families of their own and entered into the family business cycle on the island.

It was ironic, perhaps, that a somewhat clannish, provincial, unpolished, and uneducated family would cater to the whims of the rich and famous of a growing and prosperous America. Alexander Hunter, who in 1908 wrote extensively of Cobb and Hog Islands in *The Huntsman in the South*, was a farmer, writer, and gentleman (and something of a dandy) from Alexandria, Virginia, who visited the island often. Here is Hunter's description of the opening of the Cobbs' hotel:

> I happened to be there at the opening, and it made a greater impression upon me than any seaside resort I ever visited. The attempt of three simple-minded, honest fishermen to run a watering-place, without the remotest idea of anything outside their storm-tossed isle, was certainly unique and rare.
>
> Warren Cobb, the eldest son, was a rough and ready mariner, with a voice like a fog horn, and an insatiate thirst. He was a typical ruddy-faced, good-natured, weather-beaten, ocean fisherman. He never refused an invitation to "splice the main brace," and each succeeding drink only made him happier than the one before.
>
> Nathan, the second son, was a very tall, angular man, of powerful build, and withal as gentle and tender as a child. He was the only sportsman in the family, and was, without exception, the finest shot I ever met. He probably killed more wild fowl for market than any other gunner in America. With all his simplicity, he had strong horse sense, and refused to join the hotel syndicate. "Here I is, and here I stays," was his ultimatum, as he pointed to his neat house and his fine garden. So he stuck to his business, and in the course of time he owned nearly the whole island.
>
> Albert, the youngest, was the bright one of the family; he was a sport, too, but his game was draw poker.
>
> Well, the opening was a great success. However, a young, inexperienced fellow from the mainland, a friend of the family, was installed as clerk at the

hotel. But he kept no books; he carried the current sheet and ledger in his head, and at the end of the season he "skipped" and left nothing behind save his conscience, and that was probably of small value.

It was truly ludicrous, these untutored, unimaginative wreckers catering to the wants of the delicate, refined pleasure-seekers. Well, the balance was about even; these Norsemen did not understand their guests, and the guests certainly did not comprehend their landlords.

Whatever cultural differences existed between guests and landlords seem to have disappeared after a stay on the island, however. The rich and the famous came from all over the nation to visit the Cobbs' resort, and most of the guests returned many times. What the Cobbs lacked in social finesse, they made up for in hospitality, generosity, and equanimity.

The peak years for the Cobbs' hotel seem to have been the late 1870s. By the early 1880s, Nathan, Sr., was in ill health, and various reports indicate that the hotel had fallen into disrepair. The Virginia General Assembly in 1882 approved legislation incorporating the Cobb's Island Seaside Company, the purpose of which was to purchase the island and repair the hotel. Among the principals of the Cobb's Island Seaside Company was Alexander Hunter, who at that time represented the city of Alexandria in the General Assembly.

The efforts of the syndicate were short-lived, and after the Cobb family sold out, the hotel passed through a number of hands. The Crumb family operated it for a few years, then Lucius and Captain Tom Spady, a former Cobb guide, took over until a series of storms in 1896 destroyed most of the original buildings.

By 1900, any tangible evidence of the Cobb family's presence on the island had all but disappeared. A few modest clubhouses were later built on the island, and Cobb descendants and former Cobb employees continued to guide hunters and fishermen. But with the death of Nathan, Sr., in 1890 the spirit seemed to go out of the place, and despite all efforts, it was impossible to return to those magic years of the 1860s and 1870s, when through luck, hard work, and indomitable spirit, Nathan Cobb built what Alexander Hunter termed the most famous hunting and fishing resort in the Americas.

Today the Cobb legacy is an important part of the history of this narrow peninsula. The hotel has long since disappeared, and the site where it once stood is well into the ocean. What remains are the stories and the memories, and certain important artifacts. The Cobbs and their guides were exceptional decoy makers, and the wooden birds that remain from their island hunting rigs are considered some of the best ever made. Nathan, Jr., the most accomplished sportsman of the family, was a decoy carver of the first rank. His waterfowl and shorebird decoys are among the most sought-after by collectors, often bringing several thousand dollars. A goose decoy carved by Cobb sold at auction in 1986 for $34,000.

Elkanah Cobb, the son of Nathan, Jr., was also an accomplished hunting guide and carver, as was Arthur Cobb. The younger Cobbs probably learned the trade of decoy making from their father, Nathan, Sr. Although no verifiable examples of decoys by the elder Cobb are known to exist, he was known to be a master craftsman. If he did not teach his sons to carve decoys, he certainly passed on to them his skill in woodworking.

The sons, having grown up on a remote island where waterfowl and shore-birds provided both beauty and sustenance, combined their woodworking skills with an affection for wild birds to create carvings of simple, lasting beauty.

Nathan, Jr., a quiet, hardworking, practical man, would no doubt be bemused that the wooden birds he carved from the masts of salvaged ships would today be considered objects of art, selling for thousands of dollars and being exhibited in museums.

But Nathan's decoys are valuable not just because of the obvious merit of their craftsmanship. His decoys are tokens and symbols of a time that has passed us by. They are our last tangible means of holding on to an era that has gone, which we will never see again. Cobb's decoys are valuable not simply for what they are, but for what they represent.

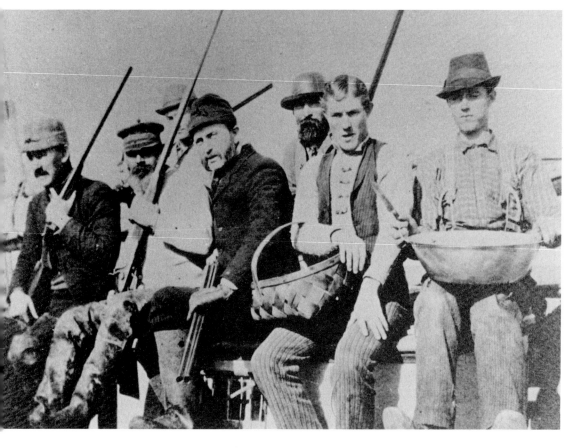

Party of duck and shore-bird hunters off Cobb Island in 1892. Elkanah Cobb is seated second from left, holding a large-bore shotgun.

Fishing at Cobb Island around 1900. Guide George Cobb is on the left, posing with an un-identified woman angler.

Alexander Hunter

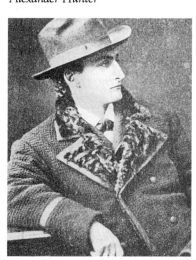

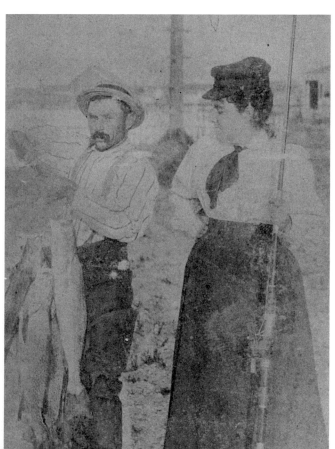

Nathan Cobb, Jr., in January 1892 on Cobb Island. Nathan's father moved his family from New England to the Eastern Shore of Virginia in the 1830s and settled near the village of Oyster. He later purchased the island that today bears his family's name, and he and his three sons, Nathan, Jr., Warren, and Albert, began a ship salvage business. The Cobbs also operated a well-known sportsman's hotel, and the family guided for hunters and fishermen.

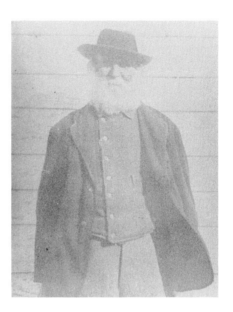

George Cobb on Cobb Island in 1932. George continued to guide hunting parties on the island until he drowned in "the 1933 storm," a major hurricane that damaged much of the barrier islands. He was one of the last residents of Cobb Island, and the last hunting guide to carry on the Cobb family tradition.

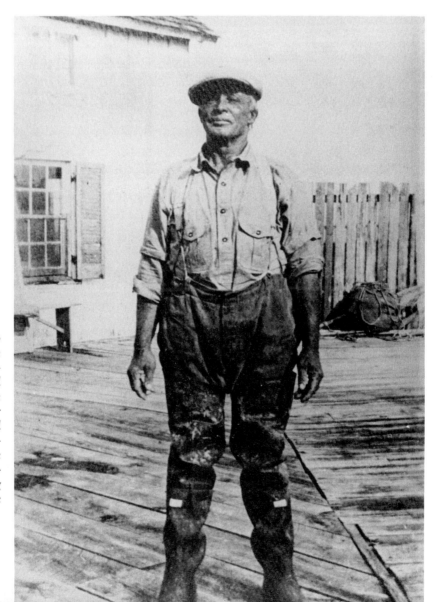

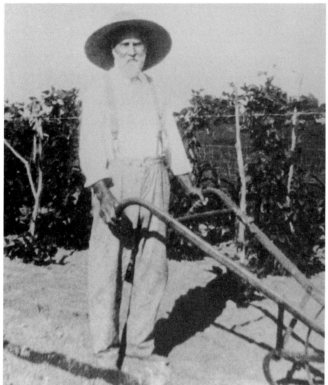

Elkanah Cobb at his family farm near Oyster in the 1930s. Elkanah was the son of Nathan, Jr., and the grandson of Nathan, the patriarch of the clan. Albert had one son, Lucius, and Warren Cobb had a son named Arthur.

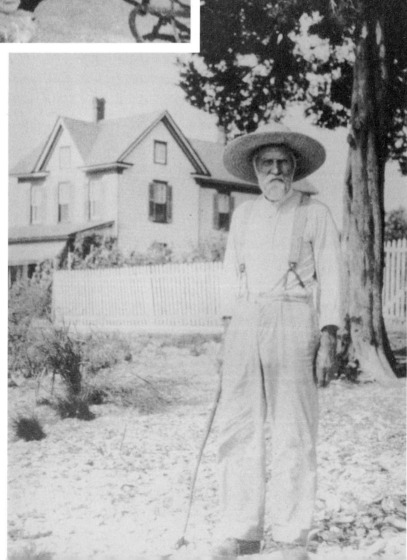

Elkanah Cobb in front of Capt. George Cobb's home in Oyster in the 1930s.

Mrs. Emory Cobb, George Cobb's wife, on the porch of the Cobb Island clubhouse in 1925.

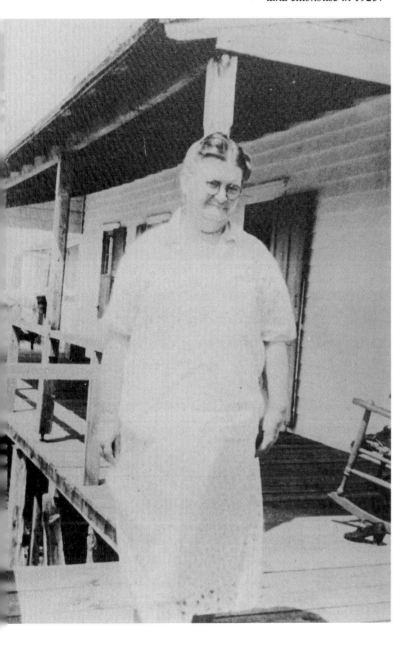

On the porch of the Cobb Island clubhouse in 1928 are, from left, an unidentified guest, Emory Cobb, and George Cobb.

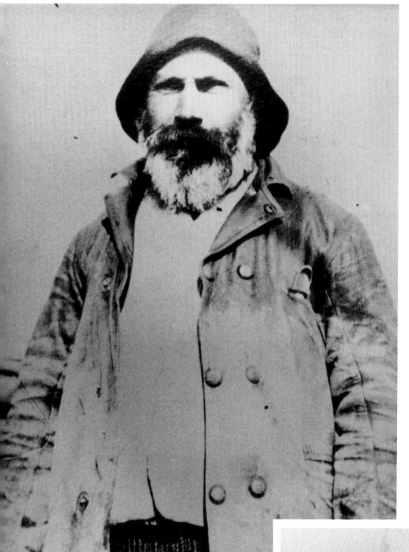

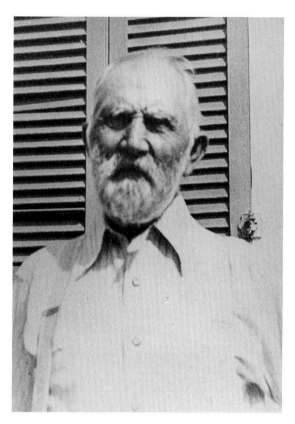

Elkanah Cobb at his home in Oyster around 1932. He died in 1943. Left, Elkanah Cobb in 1892 in his oilskins.

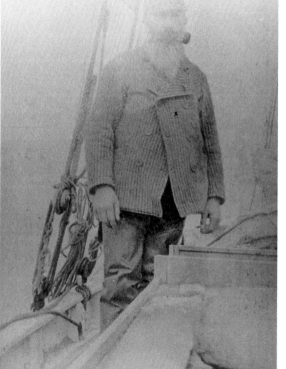

Elkanah Cobb in February 1893 on his sailboat in Cobb Island Bay.

Nathan Cobb, Jr., and his wife Sally on the porch of their Cobb Island home in 1890. The photograph was commissioned by author Thomas Dixon and was taken by Mathew Brady, the famous Civil War photographer.

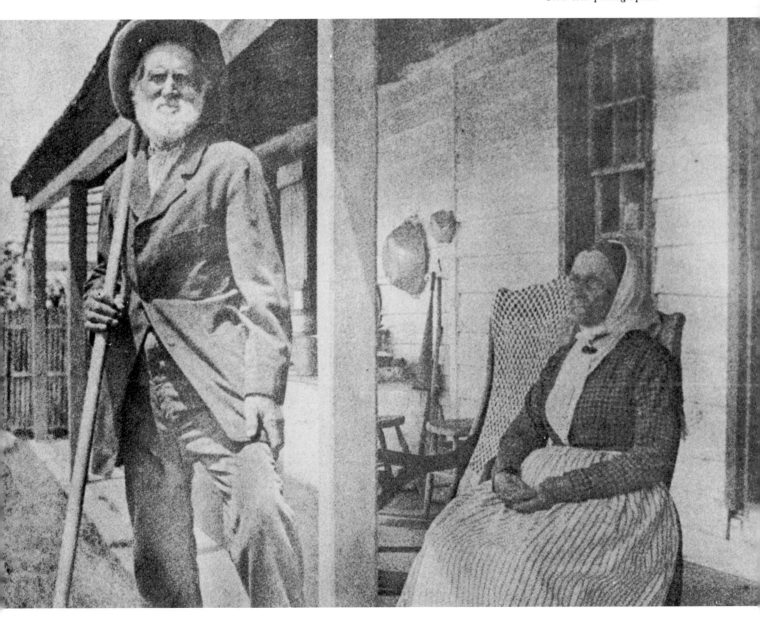

Writer Thomas Dixon, at left, and guide Capt. Jack Andrews with a day's kill of shorebirds on Cobb Island.

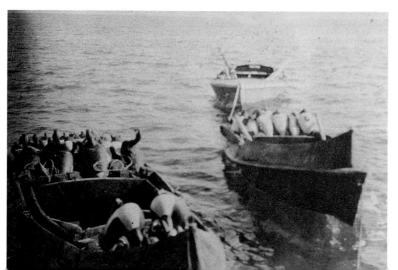

Hunting skiffs loaded with wooden decoys in Hog Island Bay around 1920. The decoys were probably made by Charlie Birch of Willis Wharf.

Hunters with ducks and brant taken in the Cobb Island area in the 1920s.

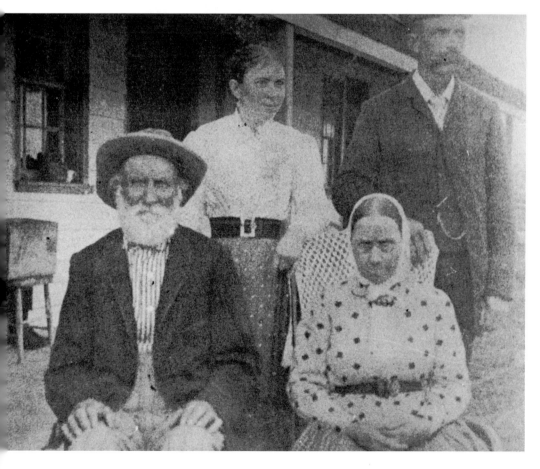

Nathan Cobb, Jr., and his wife Sally, front, and Nathan and Sally's son, Elkanah, and housekeeper, Annie Wyatt, at the Cobb home on Cobb Island in 1885. Annie Wyatt and Elkanah Cobb were reportedly lifelong sweethearts, although they never married. They are buried side by side in the Cape Charles Cemetery.

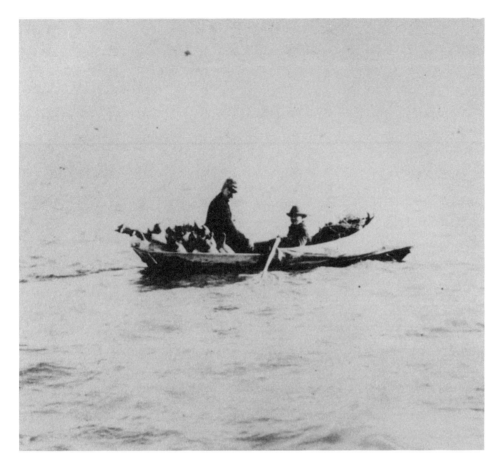

A skiff loaded with Cobb decoys, guide, and sportsman heading for the blind in December 1893.

Thomas Dixon, right, and guide with a day's bag of Canada geese. The back of the original photograph is inscribed, "To Nathan Cobb, Esq., veteran goose hunter, February 1899, Thomas Dixon."

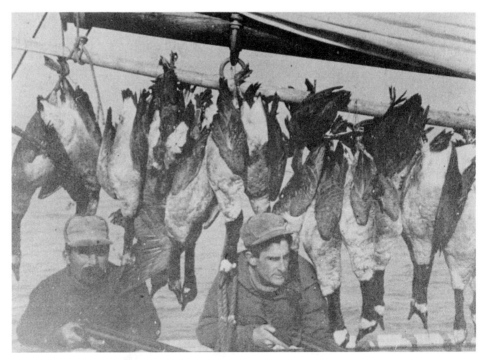

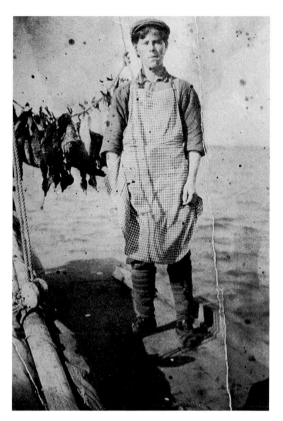

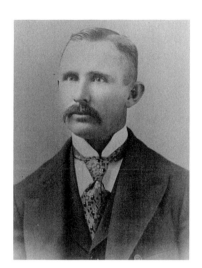

Thomas Lucius Cobb, the first cousin of Elkanah Cobb.

Cook on the stern of a sailboat in the Cobb Island area around 1920.

Elkanah Cobb's home in Oyster in 1915. His mother, Sally Cobb, is on the porch wearing a dark dress, and Annie Wyatt, Elkanah's friend, is on the left. Elkanah is in the buggy.

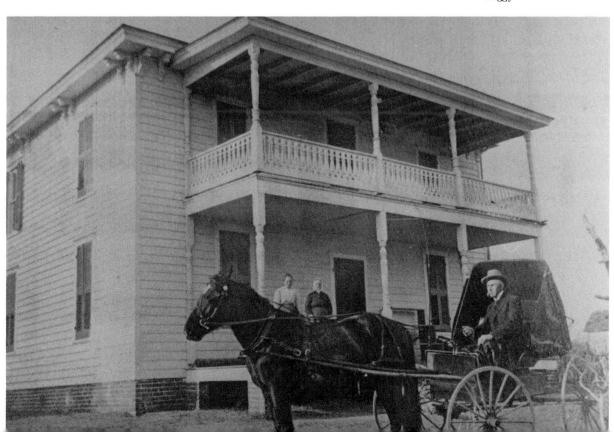

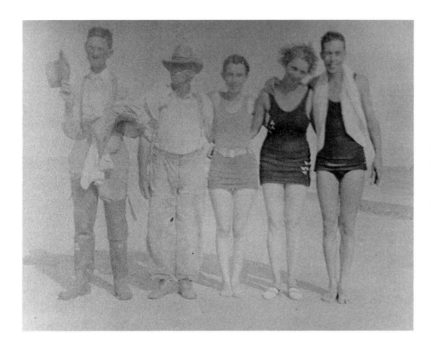

A beach scene on Cobb Island. From left, Arthur Roberts, George Cobb, Maggie Roberts Mack, and two unidentified swimmers.

From left, George Cobb and relatives Maggie Mack and Georgie Roberts in 1925 at the Cobb Island clubhouse.

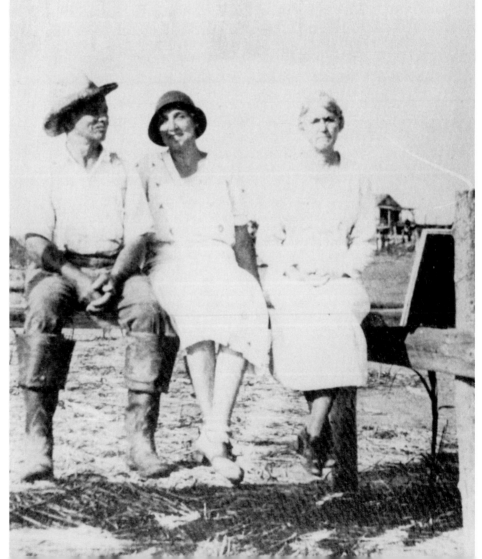

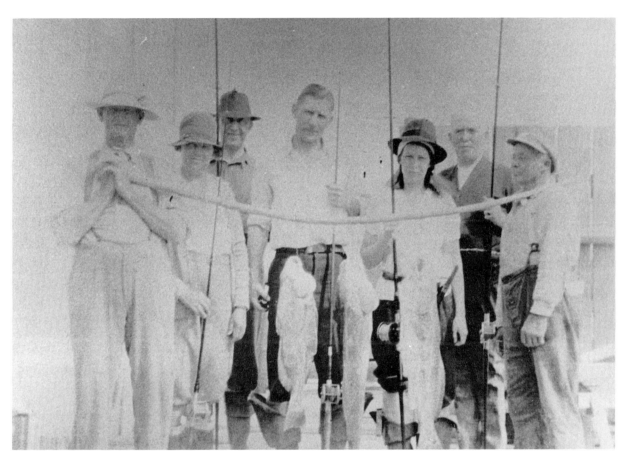

Fishermen at Cobb Island in May 1929. Guide George Cobb is on the right.

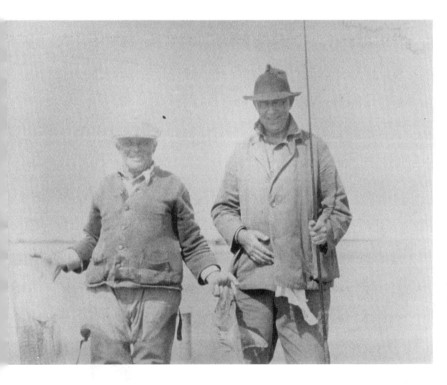

George Cobb, left, holding a red drum and shark recently caught by fisherman at right, whom Cobb was guiding. The fish were caught in the surf at Cobb Island in October 1928.

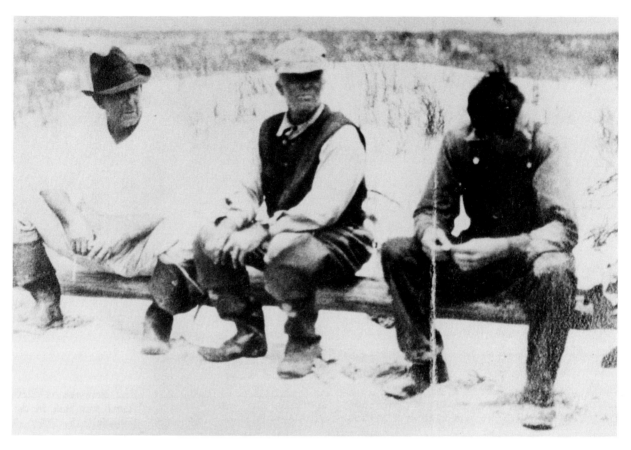

Beach scene on Cobb Island, June 15, 1930. George Cobb, center, poses with H.M. Joynes, left, and William Clark, Jr.

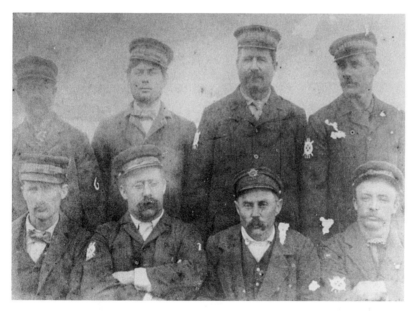

Cobb Island lifesaving crew in 1894. George Cobb is on the far right in the front row.

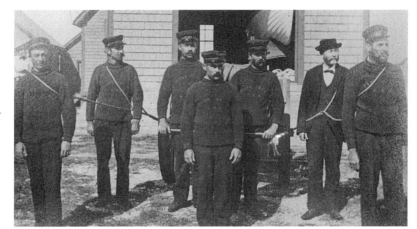

Cobb Island lifesaving crew in the 1890s.

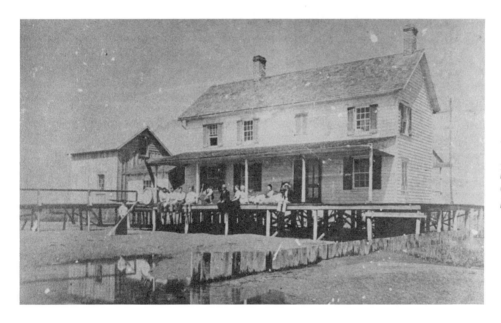

This clubhouse on Cobb Island was built in the late 1800s by Elkanah Cobb as a lodge for duck hunting parties.

Cobb Island Hotel, probably in the 1880s. This photograph was in Alexander Hunter's book, The Huntsman In The South, in which Hunter described waterfowling with the Cobb family on Cobb Island.

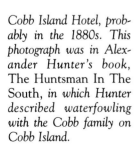

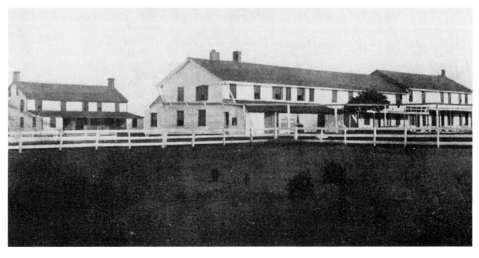

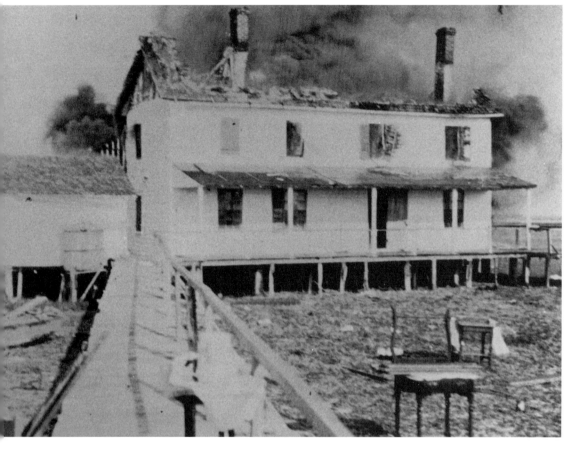

Cobb's lodge burned on May 31, 1930. Only a few personal items were saved, and the fire marked the end of the Cobb family's lodging business on the island.

A distant shot of the 1930 fire on Cobb Island. The small buildings on the right were used by the life-saving service to store flares and other flammable items. The white building on the right was Seward's Cottage.

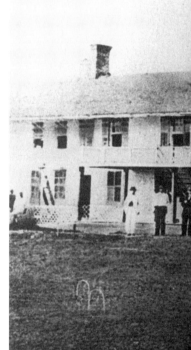

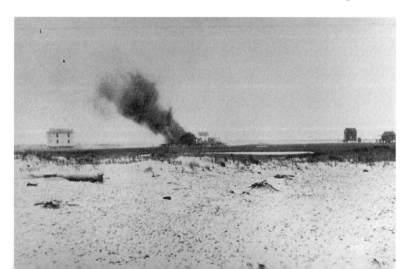

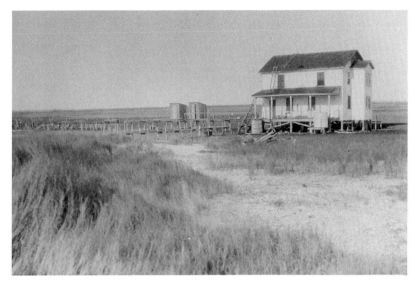

Seward's Cottage on Cobb Island in the late 1920s.

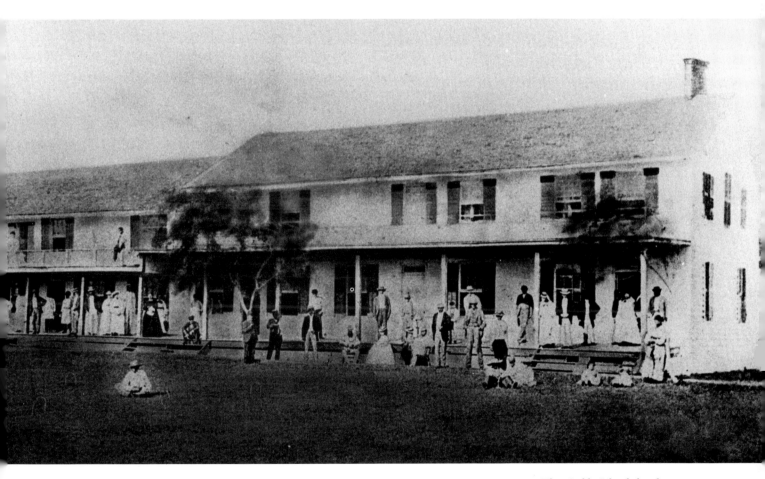

The Cobb Island hotel, with guests, in the late 1800s.

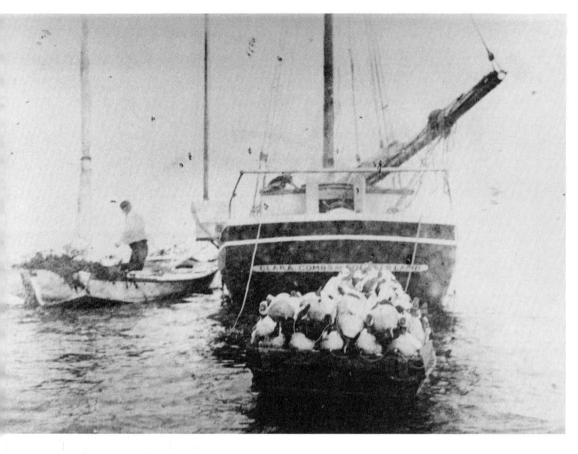

The Clara Combs was used to ferry visitors from the mainland to Cobb Island. Here, a skiff loaded with decoys is tied up at her stern, and in the boat to the left a worker is loading cedar cuttings to bush up duck and shorebird blinds.

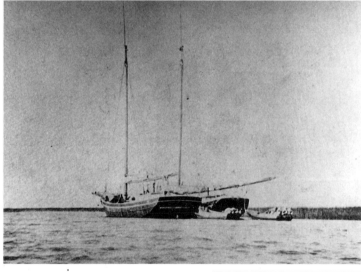

The Cobb family sailing vessel Clara Combs anchored at Loon Channel in 1893. An unidentified sailboat is tied up alongside, and both boats are towing duck hunting skiffs loaded with decoys.

The Clara Combs at anchor in Cobb Island harbor in 1890.

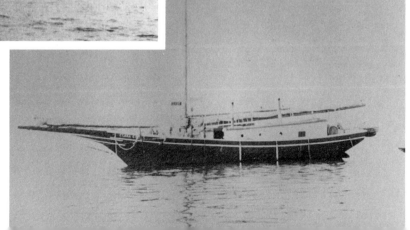

This Cobb Island scene shows the old lifesaving station on the south end of the island, right. The small buildings are oyster watchhouses. The larger building to the far left is the original lodge on Little Cobb, or Cardwell, Island. The lodge was owned by the W.D. Cardwell family of Richmond, Va., and was used by the U.S. Navy during World War I.

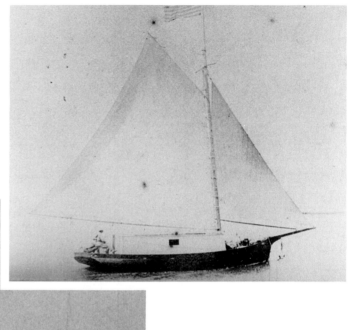

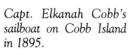

Capt. Elkanah Cobb's sailboat on Cobb Island in 1895.

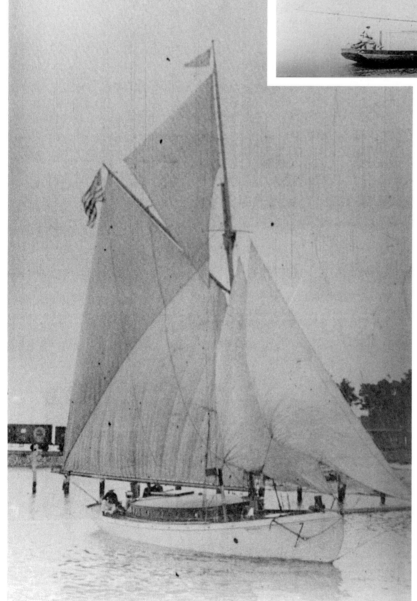

Elkanah Cobb with another sailboat entering Cape Charles harbor in the late 1890s. Note the railroad cars in the background.

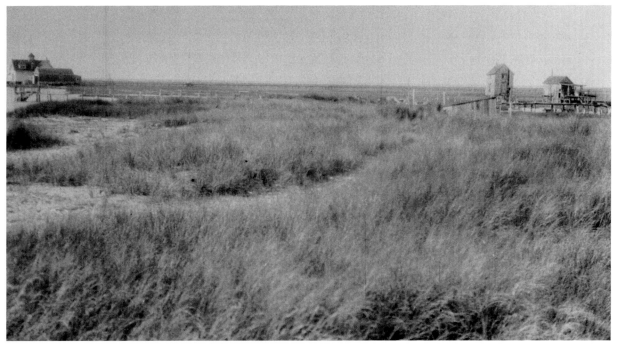

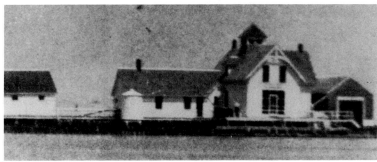

The old Cobb Island life-saving station is on the extreme left in this photograph, taken in the early 1930s, before the 1933 storm. Most of the shanties on the right were washed away in the storm.

The old Cobb Island life-saving station. Parts of this structure were washed away in storms over the years.

Cobb Island in the late 1930s, showing the new Coast Guard station just to the left of the old life-saving station. The Cobbs sold the land for the new station to the government in 1937 for $300. The building on the left is the Cardwell lodge on Little Cobb Island.

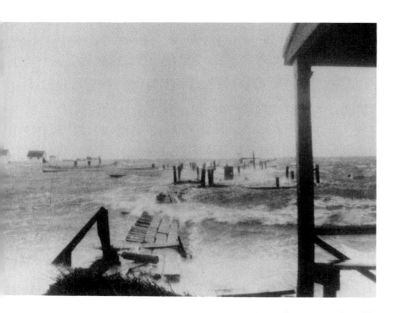

A similar view of Cobb Island taken on August 23, 1933 during the severe storm that damaged the area.

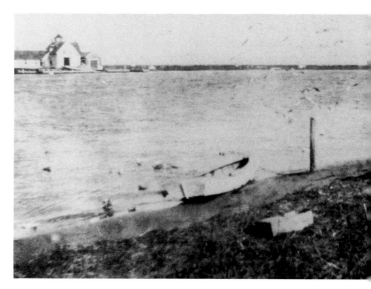

Cobb Island as seen from Little Cobb Island just prior to the 1933 storm.

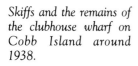

Skiffs and the remains of the clubhouse wharf on Cobb Island around 1938.

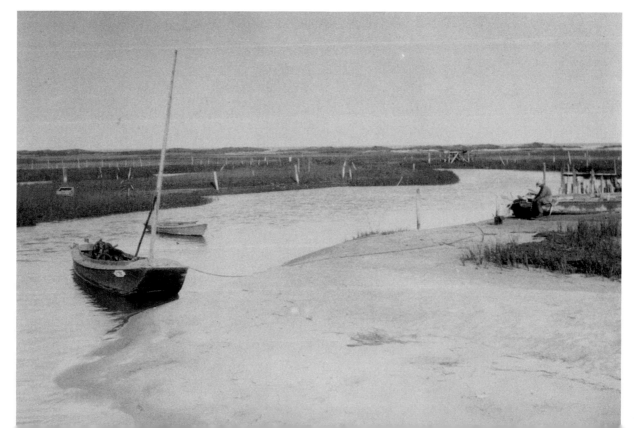

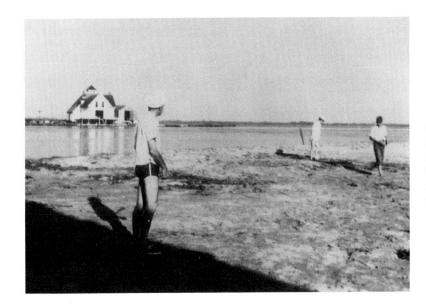

Cobb Island shortly after the 1933 storm. Note that the north wing of the lifesaving station and an adjacent building are missing.

The Coast Guard station on the south end of Cobb Island on the afternoon of the Ash Wednesday storm of 1962. A small boat was stranded on the deck behind the station, and another boat has sunk in the harbor. On the marsh beyond the station is the old lifesaving station. The Coast Guard station on Cobb was decommissioned on March 23, 1964.

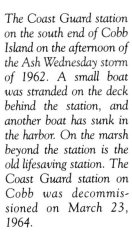

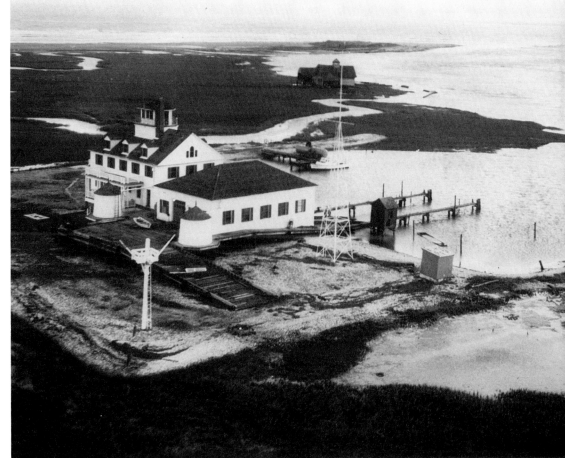

2
HOG ISLAND

A Life of Simple Beauty

Hog Island has gone by a number of names, and it has played a variety of roles in the history and culture of Virginia's Eastern Shore. It was an important hunting and fishing ground for the native American Indians. It later was home to an early colony of Virginia settlers who disappeared virtually en masse in the late 1600s. And after the American Revolution the island became home to more than 250 independent and strong-willed people, residents of the village of Broadwater, which some fifty years ago fell victim to an encroaching ocean.

The Indians named the island Machipongo, but when Captain John Smith explored it in 1608, he referred to it on early charts as Shooting Bears Island. How the island came by its present name is open to speculation. Some say a ship carrying hogs wrecked on the treacherous shoals that fringe the seaward edge of the island, and that the hogs swam ashore and established a feral population. Another theory holds that the island's name is an abbreviated version of quahog, the hardshell clam found in abundance in the island waters.

The earliest record of European settlement on the island came in 1672 when twenty-five colonists were granted a patent to the island, and they lived there for an undetermined time. No one knows what became of the settlement. The colonists disappeared—man, woman, and child—leaving no clues as to their fate, no history or written record, no descendants to pass on the word of their misfortune. The disappearance is as mysterious as that of Sir Walter Raleigh's Lost Colony of North Carolina. Were the settlers victims of Indian attack, of disease, or were they all claimed by some great unrecorded natural disaster?

No other record of human habitation exists until Labin Phillips settled there during the American Revolution. After the war, more and more settlers were drawn to the remote island, where they found plentiful game and fish, and fertile soil for gardens. The earliest settlers, in the years preceding the marketing of waterfowl and shellfish, made their living by salvaging vessels that had grounded and wrecked on the nearby shoals. It was not until 1853 that the federal government built a lighthouse on the island, followed twenty years later by a lifesaving station.

The settlement grew in the late 1800s, and by the turn of the century there were more than 250 persons on the island, making it the most populous of the barrier islands. A church was built in 1880, and Captain Charles Sterling, in his 1903 history of Hog Island, reported that the island boasted a school with thirty-four students, a hotel, two stores, and a sportsmen's club.

The sporting life drew people to Hog Island. Wrote Sterling:

> Hog Island is, at certain seasons of the year, ideal ground for the sportsman. Machipongo Inlet and its channels is a famous feeding ground of the wild geese and that king of wild fowl, the brant, and the marshes abound with black duck. In the spring and summer the curlew, willet, and graybacks flock to the oyster shoals and ponds in the meadows . . .
>
> In the creeks, channels, inlets, and ocean are found every variety of fish. The delicious hog fish and sheepshead are found in abundance. Fine fishing is the rule and not the exception.
>
> The marshes abound in soft crabs. On the sandy beach the clams are taken in numbers either to fill a canoe or a ship. And then the diamond back terrapin has its home in the creeks that run through the swamps and estuaries that border the place. Indeed nature has so bountifully endowed Hog Island that it discounts the fabled island of Calypso.

Nature's bountiful endowment accomplished two things for Hog Island. It attracted to the island a group of independent, self-reliant individuals who sought freedom from the social and economic constraints of living in mainland towns. The plentiful fish and game also attracted wealthy sportsmen from northern cities, some of whom purchased land and built hunting lodges in the island village of Broadwater.

While some villagers quickly discovered that catering to wealthy visitors was an easier way to make a living than dredging oysters or raking clams, the majority opinion was not in favor of the wealthy northerners who had come in the name of sport to harvest the bounty of the island. Despite Sterling's glowing description of Hog Island's natural resources, island life could be harsh and demanding. The isolated life of the islanders was tied closely to the natural scheme of things; they caught their supper with their hands, they paid only with their labor, and they assumed with good grace that they would suffer through cycles of privation, then reap their profits when nature was generous.

Such an existence produced people of simplicity, directness, independence, and self-reliance. To live such a life was to accept the benevolence of nature without questioning, because what was given today might well be taken away tomorrow.

Two histories of Hog Island provide fascinating views from separate windows. Charles Sterling's forty-page history was published in 1903. Sterling was keeper of the Hog Island lighthouse from 1901 until 1907, and his account ennobles the island and its people. In 1908 Alexander Hunter, an Alexandria, Virginia, farmer, politician, and writer, published a wonderful book entitled *The Huntsman in the South*, an anthology of hunting adventures in Virginia and North Carolina. One of the most interesting chapters of Hunter's book deals with Hog Island.

About half of Hunter's history is verbatim Charles Sterling. The beginning paragraphs are word-for-word, and much of the other information was apparently lifted directly from Sterling's history without so much as a misplaced comma. Did Hunter plagiarize Sterling? The date references certainly indicate that he did. But many of Hunter's collected stories had been published previously in periodicals such as *Forest & Stream*, so could it actually have been Sterling who was guilty in this case of the purloined prose?

Hunter's history and Sterling's account are virtually identical through much of the discussion, but the conclusions drawn by the two writers are poles apart despite being based upon identical factual information. Here is Sterling's idyllic description of life on Hog Island: "The community is as peaceful as the inhabitants of Rasselas' Happy Valley. There is no justice of the peace, no constable, no machinery of the law, for amongst this law-abiding, God-fearing set, there has not been a crime committed within the memory of man."

Hunter argues that there is another reason for the low crime rate: "Living in a land where no one need work, and where nature has given them a fine climate, the ocean and land, and food in plenty, we might expect to find as ideal a community as ever existed in Rasselas' Happy Valley; but such is not the fact. The islanders are below mediocrity. There are some bright examples, but the majority are slothful, and their dispositions mean and malicious. There are no criminals among them, for the reason that they have not the energy or spirit to commit a crime, except in the breaking of the game laws. They fish and hunt, and labor for a few weeks gathering oysters, and this labor gives them enough money to live at ease and comfort. Most of these islanders hibernate like an animal; they eat heavily, and then doze for hours. Some of them recline and repose twenty-four hours out of the twenty-four."

The amazing aspect of this story is that Hunter returned to hunt with the islanders numerous times—amazing, that is, that he survived to hunt numerous times. Hunter was probably one of America's most foolhardy outdoor writers; how else to explain why he would write such articles, then accompany the subject of the article on a remote, isolated island with the subject armed with a twelve-gauge shotgun?

Then, too, there is the possibility that Hunter's barbs were delivered with tongue planted firmly in cheek, and were accepted in that light by the victims.

The point on which Hunter and Sterling agreed was the abundance of fish and game, a resource greatly coveted by the sporting public but jealously guarded by the island residents. Wealthy industrialists and politicians from the North purchased property on the island, and opulent hunting clubs were built. But the tourism industry was not sanctioned by the majority of the islanders, and it was hotly opposed in many instances. Hunter writes that the islanders could have made a fortune by accommodating yachtsmen, hunters, fishermen, and vacationers. "Instead they acted with malice toward strangers and deliberately practiced night-shooting to drive the waterfowl from their feeding grounds and away from the blinds of the wealthy clubmen until the strangers withdrew in disgust."

Before the great beds of eelgrass disappeared from the seaside Eastern Shore in the late 1920s, tens of thousands of brant wintered in the bays that separate the barrier islands from the mainland. One of the most remarkable passages in Hunter's Hog Island narrative describes a late-night December storm observed from the lighthouse, where thousands of brant were hovering blindly around the intense light.

After an unsuccessful day of hunting, Hunter retired for the night and was awakened at 2:00 a.m. by the assistant lightkeeper, who told him that the brant were flocking by the thousands around the lighthouse. The two men put on their oilskins and slowly made their way across the enclosure and up the spiral steps of the tower. From the shelter of the keeper's room, which was just under the 200-foot-high light, they watched as the great flock of brant became mesmerized by the intense light.

The brant, the shyest, wildest, most timid of waterfowl, were within five feet of us, but, evidently blinded by the light, they could see nothing. Some would circle around the tower, others dart by; and wonderful to relate, some would remain stationary in the air, their wings moving so rapidly that they were blurred like a wheel in rapid motion. I thought at the time what a tremendous power must lie in their wings to enable them to nullify the wind that the instrument inside indicated was blowing at sixty-five miles per hour.

The lamp in the tower revolved every forty-five seconds, and for a short time every bird was in the vivid glare, which displayed every graceful curve of neck and head, and the set and balance of the body, and enabled one to look into their brilliant eyes.

The brant is not a glossy, showy bird like the wood duck or mallard, but in the driving rain and under the powerful rays of the lamp they were exquisitely beautiful, their plumage looked like ebony, and the tints changed to many an iridescent hue. Every few seconds, above all the rush of the wind, would be heard a loud tinkling sound as a blinded brant, dazed by the rays, would strike the double

two-inch plateglass that surrounded the burner, and fall dead from the impact; sometimes dying on the platform of the tower, but more often falling on the ground.

On the night of the storm, Hunter had been staying in the lightkeeper's quarters with his fellow historian, Charles Sterling. Sterling, wrote Hunter, picked up twenty-eight dead brant, and at the base of the tower, islanders and their dogs collected dozens of dead or stunned waterfowl, "the exact number they never divulged."

While most of us will probably react to the story with sympathy for the unfortunate brant, to the islanders it was a serendipitous event. When nature is your provider, it is wise to accept such gifts as they come, because such benevolence is rare.

The people of Hog Island represented the final chapter of Virginia's colonial spirit. They were opportunists, and their disdain for the sporting aspects of the hunt made them ready targets for fair-minded writers such as Hunter. But Hunter probably understood these island people well enough to know that their refusal to bend to social constraints was certainly not a matter of contempt for the wildfowl, or even for the society that had imposed hunting restrictions. The islanders believed strongly in independence and self-reliance, and they had overwhelming, if naive, confidence that God and nature would provide for them, that the waterfowl would continue to come in great numbers, that the fish would always fill their nets, that the oysters would always grow fat and fertile. Perhaps no group of people had a more intimate relationship with the land and the sea and with the Creator who supplied this bounty.

It is not surprising that the village did not survive the twentieth century. The islands had withstood numerous violent coastal storms and floods, but it was the more subtle process of erosion that finally doomed the village. In the 1920s and early 1930s, the shoreline was disappearing at an alarming rate, and the great pine forests that had covered the upland part of the island were being claimed by the ocean. Even the most stubborn islanders realized that the days were numbered for their village. So, more than fifty years ago, the homes, church, school, and stores were jacked up and loaded onto barges, and a mass migration was begun. In a few years, all of the substantial buildings on the island, with the exception of the two Coast Guard stations, were moved to the mainland. Numerous homes in the Eastern Shore towns of Oyster and Willis Wharf were once part of the village of Broadwater on Hog Island.

Even if it were not for the encroaching ocean, the village was probably already doomed, in spirit if not in fact. By the 1930s, modern travel and communication endangered the islanders' way of life just as surely as the encroaching Atlantic. Just as nature abhors a vacuum, modern society abhors isolation and individualism. If the village existed today, it would certainly not be as Alexander Hunter and Charles Sterling knew it. Perhaps it is better that the village died when it did, so that now it can be remembered by those who lived there as an uncommon place of great beauty and natural gifts, a place where life was perhaps harder than it is today, but infinitely more rewarding.

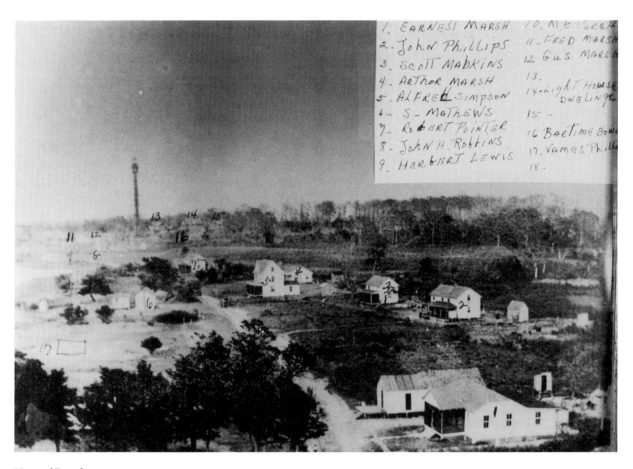

1. EARNEST MARSH
2. JOHN PHILLIPS
3. SCOTT MADKINS
4. ARTHOR MARSH
5. ALFRED SIMPSON
6. S. MATHEWS
7. ROBERT POINTER
8. JOHN H. ROBBINS
9. HERBERT LEWIS
10. M.E. (?)
11. FRED MARSH
12. GUS MARSH
13.
14. LIGHT HOUSE DWELLING
15.
16. BAELIME BOW(?)
17. VAMES PHILL(?)
18.

View of Broadwater community. The houses were numbered by Broadwater native Harvey Bowen and keyed to owner. The 1896 lighthouse is in the background.

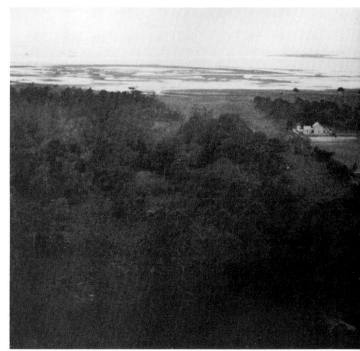

Aerial view of Wharf Creek on Hog Island. The Coast Guard station and a hotel, built in 1898, are at the tip of the island.

Broadwater community in the early 1900s showing the south end of the island.

SMITHSONIAN INSTITUTION PHOTOGRAPH NUMBER 87-3127.

Aerial view of Hog Island showing the main island road, right, and the 1852 lighthouse in the background. At that time the lighthouse was quite a distance from the beach, but the site is now under water.

Schaeffer Cottage, a private hunting club and summer residence on Hog Island, in a photograph taken around 1910.

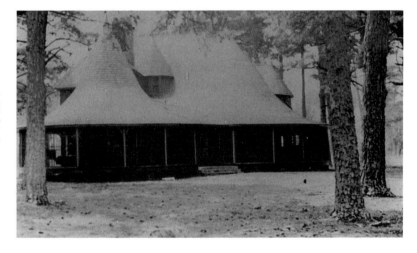

Ferrell Cottage, also a private hunting lodge, around 1910.

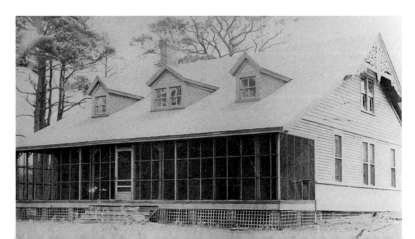

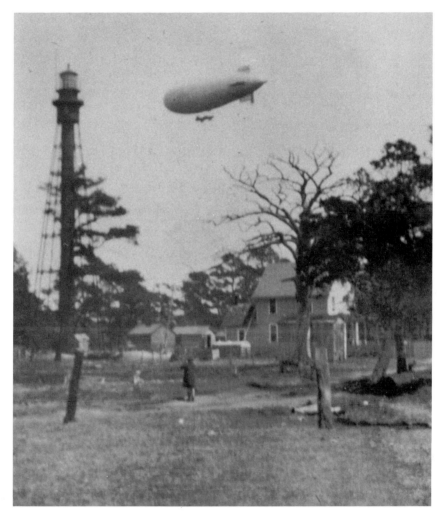

Dirigible over the 1896 Hog Island lighthouse in the late 1920s.

The original U.S. Life-saving Station, approved by Congress in 1874 and built about two years later, on the southern tip of Hog Island in a photograph taken in the early 1900s.

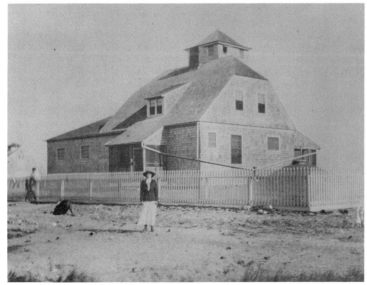

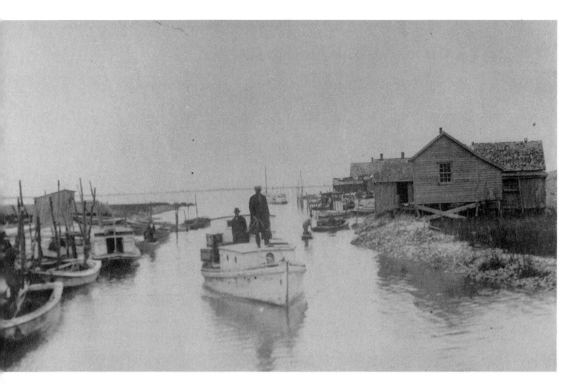

Wharf Creek on Hog Island around 1920. The mail boat Handy is coming in to the landing. Alma Simpson was the mail carrier at that time.

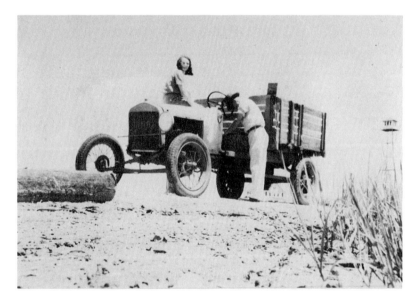

John L. Marshall's truck on the south end of Hog Island at the mail boat landing. Pictured are Pauline Phillips and John L. Marshall.

The Broadwater ceme-
tery in the mid-1930s.
The site is now under
water.

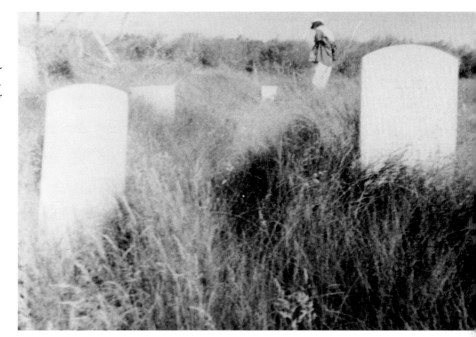

A visitor poses for the
camera near the Broad-
water cemetery in the
1930s. Note how the tide
has washed over the is-
land, damaging trees in
the cemetery area. Ero-
sion claimed this portion
of the island not long
after the picture was
taken.

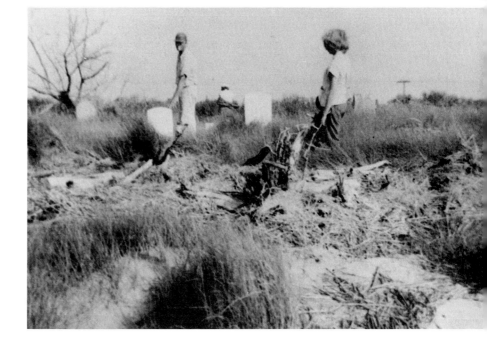

The Broadwater ceme-
tery just before it was
claimed by the ocean in
the late 1930s.

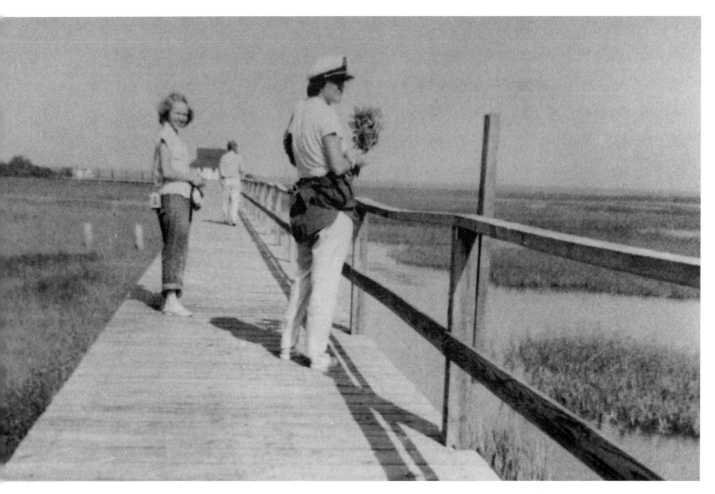

Visitors on the boardwalk that connected the Coast Guard station with the boathouse, circa 1930.

Rear view of the Coast Guard station on the south end of Hog Island in the early 1930s.

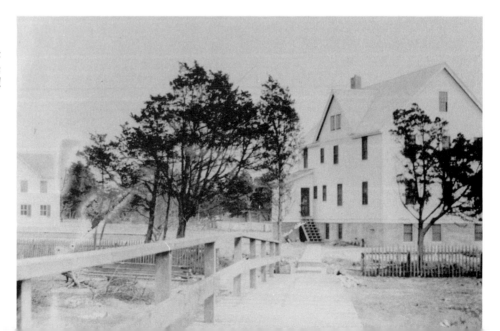

Sand dunes on Hog Island in the 1930s as the island was eroding badly.

The state boat Hornet, which was used to patrol Virginia waters by the commission of fisheries.

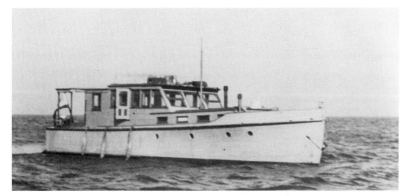

Two state boats, the Chesapeake, *right, and the* Machipongo.

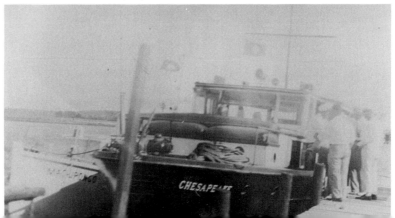

The Broadwater Post Office and general store in the early 1900s. The building is now a residence in Willis Wharf.

The residence of Mr. and Mrs. Wendell Bowen on Hog Island. The home was moved to Willis Wharf in the 1930s when the island began to erode.

The Harvey Bowen residence on Hog Island in the late 1920s.

SMITHSONIAN INSTITUTION PHOTOGRAPH NUMBER 87-3117.

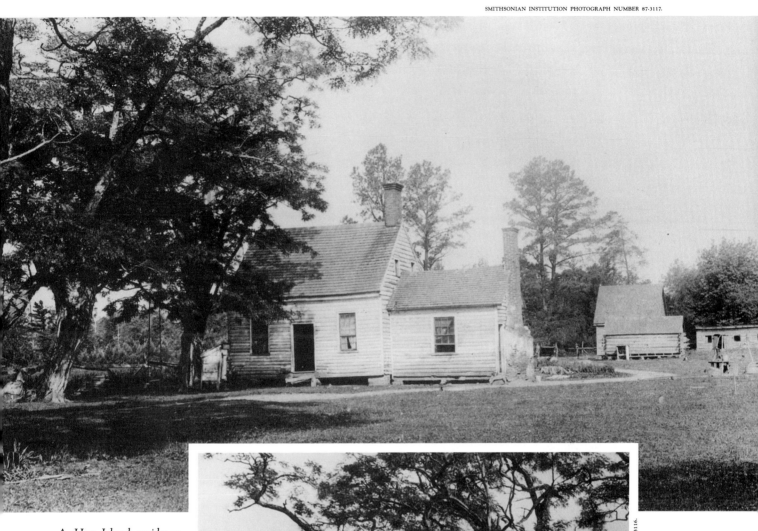

A Hog Island residence probably dating to the eighteenth century. The photograph was taken by Rudolph Eckemeyer in 1902.

SMITHSONIAN INSTITUTION PHOTOGRAPH NUMBER 87-3116.

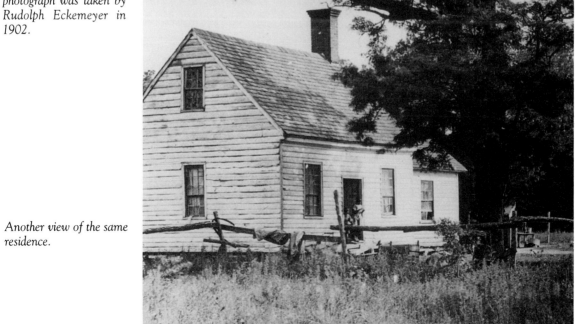

Another view of the same residence.

SMITHSONIAN INSTITUTION PHOTOGRAPH NUMBER 87-3122.

A very early residence on Hog Island, probably built in the early 1700s. The photograph was taken around 1902.

The Broadwater Methodist Church and cemetery in the 1920s. The church is currently in Oyster, and is part of the Methodist church in that community.

SMITHSONIAN INSTITUTION PHOTOGRAPH NUMBER 87-3099.

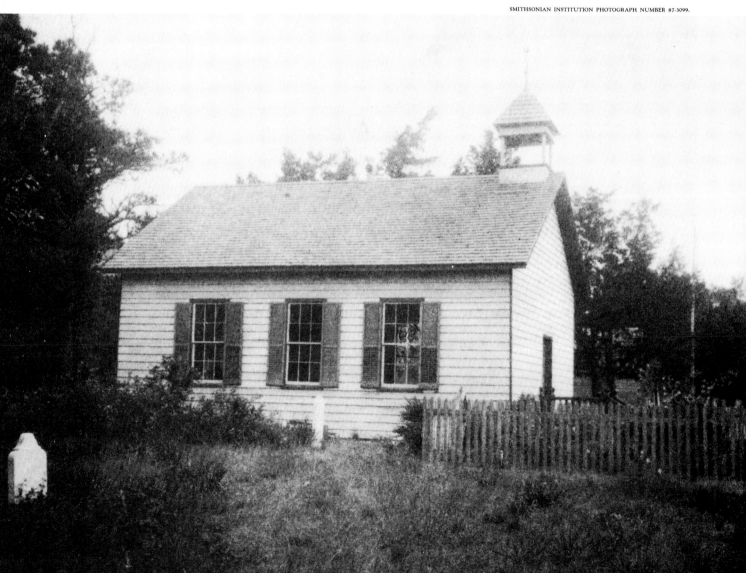

Sheep and other livestock on Hog Island, late 1800s.

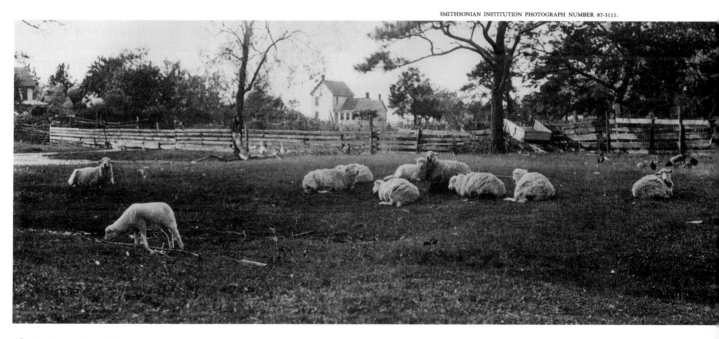

Sheep in a Hog Island pasture, late 1800s. Elton Doughty's home is in the background.

Sheep grazing on Hog Island. The 1896 lighthouse is in the background on the left.

Dirt lane that ran north–south along Hog Island.

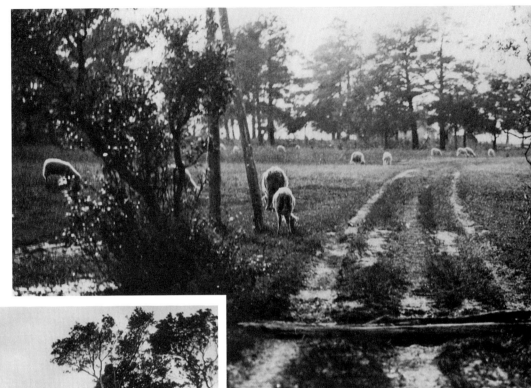

SMITHSONIAN INSTITUTION PHOTOGRAPH NUMBER 87-6891.

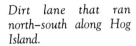

Sheep grazing on the marsh, Hog Island, around 1900.

Cattle roamed the sand dunes of Hog Island in the late 1800s.

SMITHSONIAN INSTITUTION PHOTOGRAPH NUMBER 87-6894.

SMITHSONIAN INSTITUTION PHOTOGRAPH NUMBER 87-6892.

SMITHSONIAN INSTITUTION PHOTOGRAPH NUMBER 87-3119.

A view of Hog Island, possibly taken from Rogue's Island.

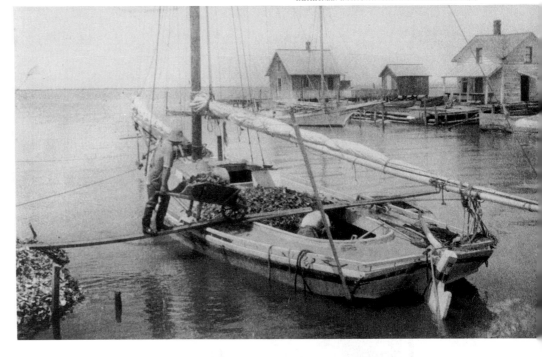

The harbor at Hog Island. Workmen are unloading oysters from a sailing schooner. The buildings in the background were used for shucking scallops and oysters.

The beach road on Hog Island.

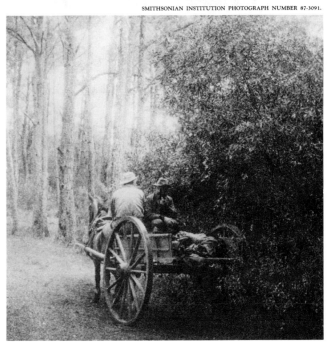

George Doughty, the keeper of the Hog Island lighthouse, gets a buggy ride on the road to the beach.

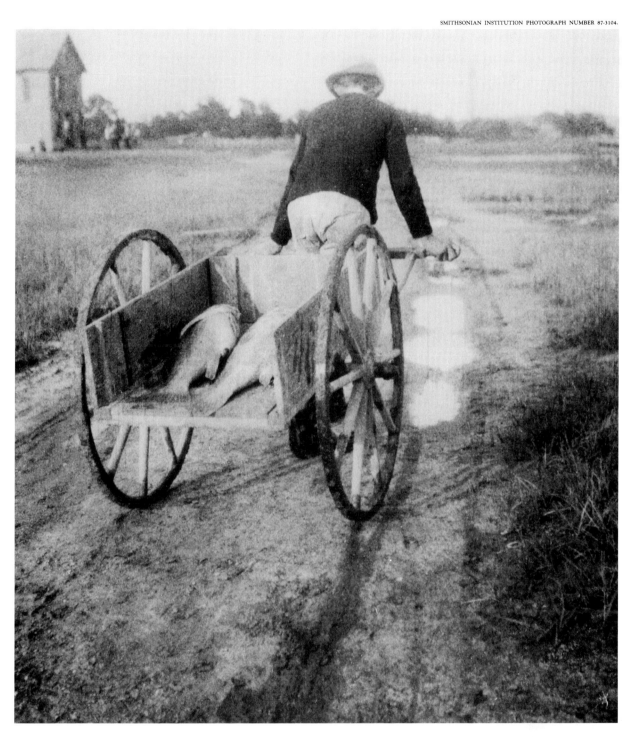

A fisherman returns to Broadwater from the boat landing with a pair of drum, circa 1900.

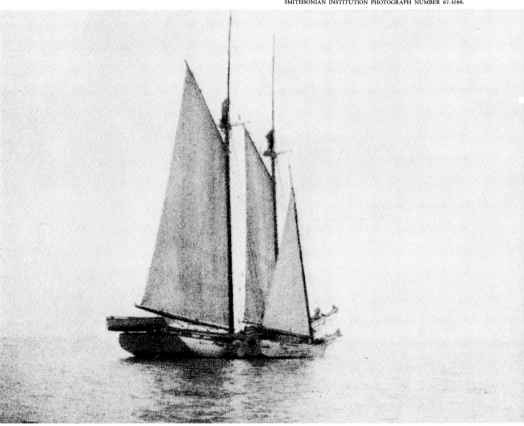

Workboats in the channel between Hog and Rogue's Islands. Fishermen are probably transferring oysters from the small sailboat to the large "buy" boat.

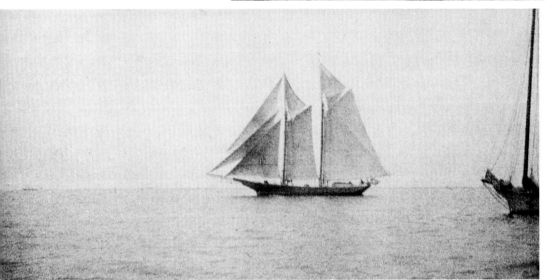

A large sailing vessel off Hog Island. The boat was probably a "buy boat," which anchored at Hog Island to purchase seafood from local watermen.

SMITHSONIAN INSTITUTION PHOTOGRAPH NUMBER 87-3106.

A double-masted schooner off Hog Island, probably loaded with seafood and produce for northern cities.

Watermen dredging scallops in Broadwater Bay at the turn of the century.

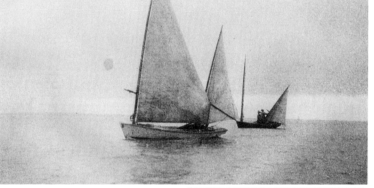

A small sailboat was the most popular form of transportation around Hog Island. Island residents used the boats for work, pleasure, and commerce with the mainland.

SMITHSONIAN INSTITUTION PHOTOGRAPH NUMBER 87-3105.

SMITHSONIAN INSTITUTION PHOTOGRAPH NUMBER 87-3098.

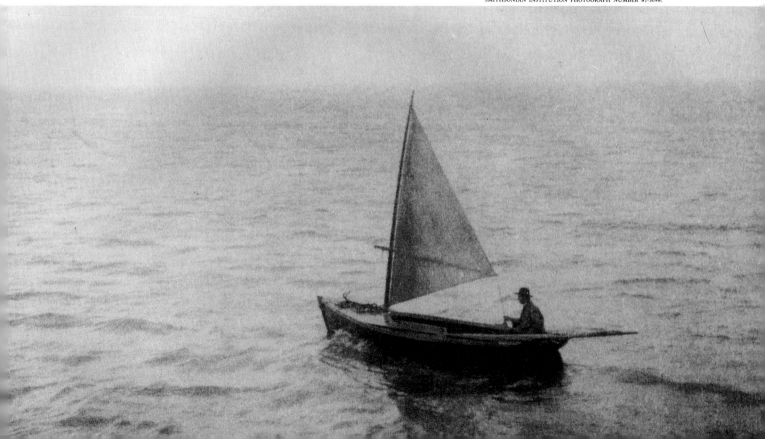

SMITHSONIAN INSTITUTION PHOTOGRAPH NUMBER 86-12732.

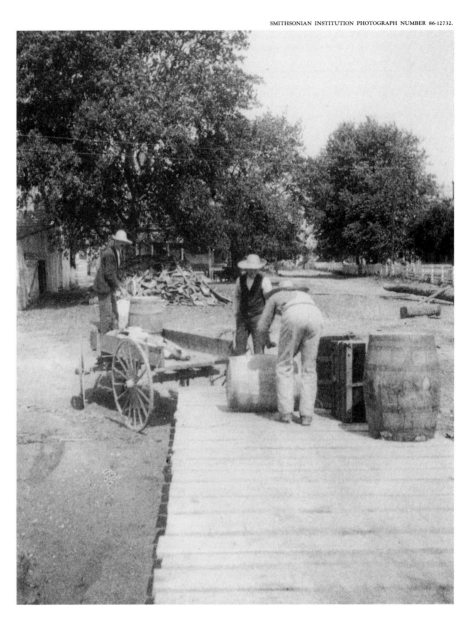

Hog Island seafood being unloaded at the dock at Willis Wharf in the early 1900s.

SMITHSONIAN INSTITUTION PHOTOGRAPH NUMBER 86-12741.

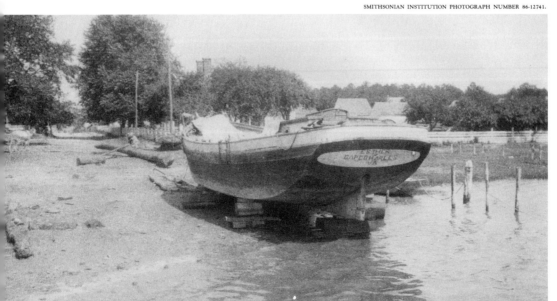

The schooner Esther, which sailed out of Cape Charles, in dry dock at Willis Wharf.

SMITHSONIAN INSTITUTION PHOTOGRAPH NUMBER 86-12742.

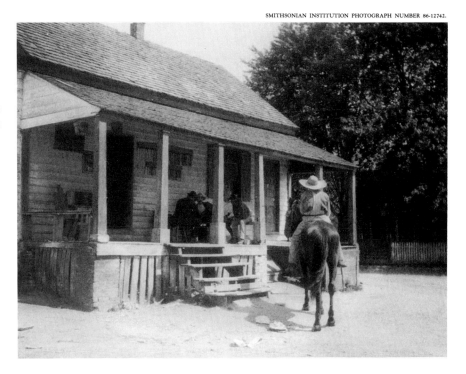

General Store at Willis Wharf at the turn of the century.

Willis Wharf harbor in the 1960s, before the new marina, in a photograph taken by Ted Ward.

A sailboat docked at Bagwell's Mill, up Parting Creek from Willis Wharf in 1902. The boat was owned by Captain Rue.

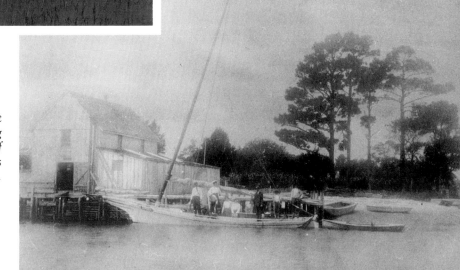

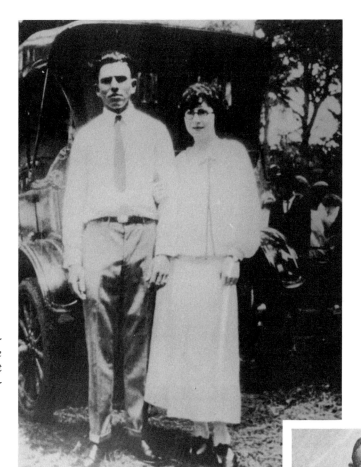

Harvey and Anna Bowen on Hog Island in the 1920s with one of the first motor vehicles on the island.

Decoy carver Dave "Umbrella" Watson, who was born in Chincoteague but spent much of his life in Willis Wharf. Many of his decoys were used in the Hog Island area.

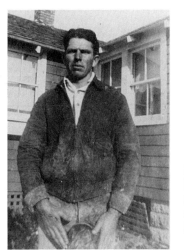

Harvey Bowen at his home on Hog Island in the 1920s. Bowen was one of the last residents to leave the island in the late 1930s.

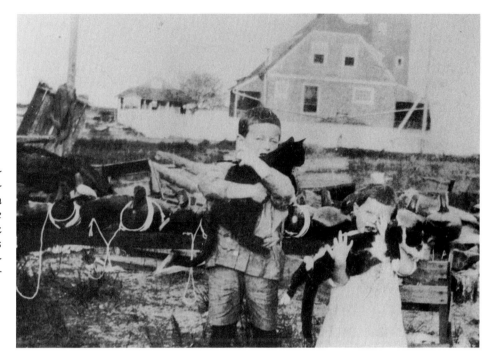

Two island children behind the original lifesaving station on the south end of Hog Island. Note the decoys on the rack behind them. The decoys were made locally, probably by Eli Doughty or Cobb hunting guides.

Bob and Marion Bowen, children of Harvey and Anna Bowen, on Hog Island.

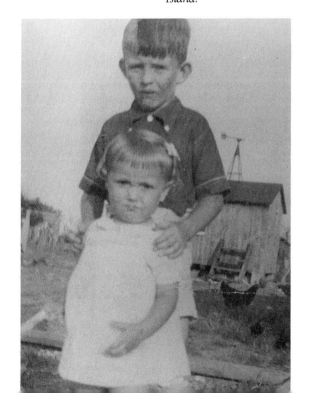

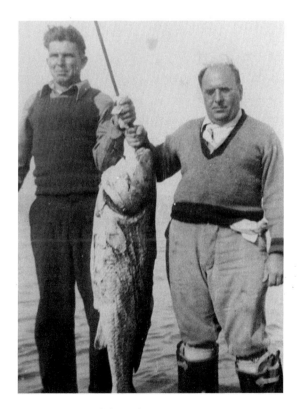

Harvey Bowen, left, and a fishing companion hoist a red drum taken near Hog Island.

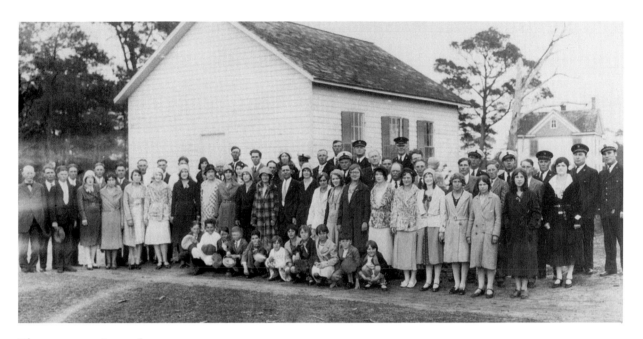

The congregation of Broadwater Methodist Church pose for a group picture in the early 1930s.

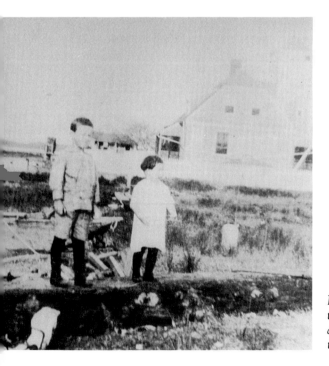

Broadwater children with the Hog Island lighthouse and Broadwater Bay in the background.

Broadwater school students in the 1920s. The teachers are Mrs. Mildred Smith, left, and Mrs. Gladys Drummond.

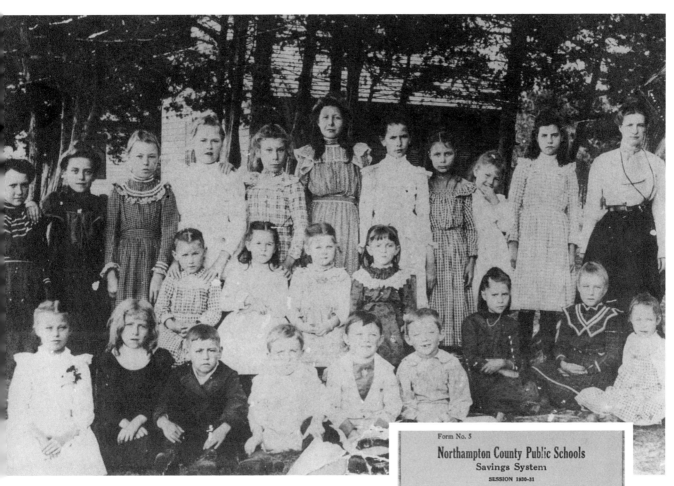

Another Broadwater student group, this one from the early 1900s.

The Planter's Bank of Machipongo recruited young savers on Hog Island with this Pupil's Deposit Card. Students earned three percent interest and could withdraw money only at Christmas and at the close of the school year.

Form No. 5

Northampton County Public Schools
Savings System
SESSION 1930-31

PUPIL'S DEPOSIT CARD

The Planters Bank, Inc.
(Machipongo, Va.)

Name of Depositor _____

_____ *Grad* **Broadwater School**

RULES

1. Deposits can be made only on Monday of each week. Any sum will be accepted, but it is suggested that pupils deposit not less than five cents.
2. All deposits must be recorded on the Pupil's Deposit Card in ink by the teacher at the time it is received from the pupil. A duplicate of each Deposit Card must also be kept by the teacher and filed in the principal's office.
3. Withdrawals are permitted only twice a session just preceding the Christmas holidays and near the close of the session. The only exceptions to this rule are the death of the depositor or his removal from the city. No withdrawal will be permitted without the written request of the parent.
4. Interest will be awarded at the close of each term on even dollars, at the rate of 3%.
5. This account is opened by and with the consent of the pupil's parents, who promise to encourage the child in thrift habits and to abide by the above rules.

START A BANK ACCOUNT WHILE YOU ARE YOUNG, YOUR FUTURE SUCCESS DEPENDS LARGELY ON YOUR ABILITY TO SAVE

Copyright 1926 Patent Applied for
AMERICAN THRIFT CORPORATION
Sole Owners and Manufacturers
Richmond, Virginia

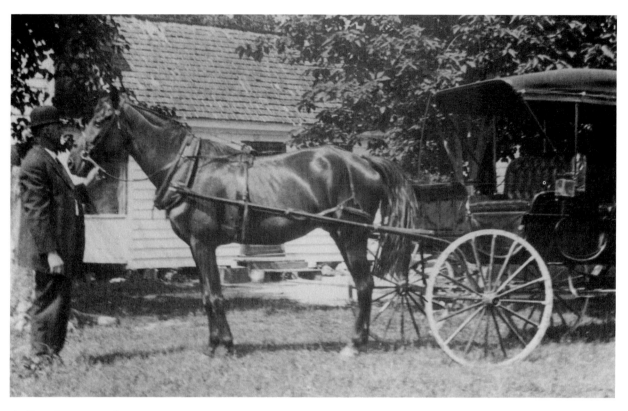

A Broadwater resident shows off his handsome horse and buggy.

Mrs. George Doughty in front of the Hog Island lighthouse.

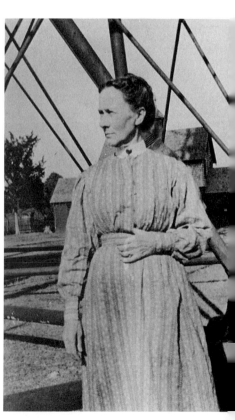

Mrs. Mae Bowen on Hog Island in the 1920s. The 1896 lighthouse is in the background.

Mrs. Doughty at her home in Broadwater.

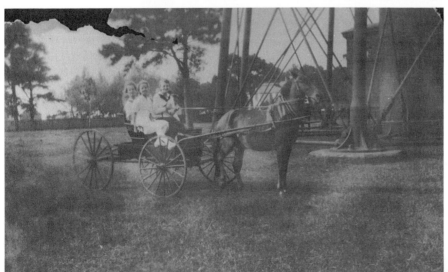

A group of young people on an outing on Hog Island near the turn of the century.

Two young women pose for the photographer in front of the two Hog Island lighthouses. The brick lighthouse was decommissioned when the new steel one was built in 1896.

Sheep-shearing on Hog Island. From left, Russell Bowen, Arthur Marsh, Ray Phillips, Fred Marsh, Elmer Doughty, Harvey Bowen, John Higbee, Harry Bowen, Otto Phillips, Raymond Phillips, and Earl Doughty.

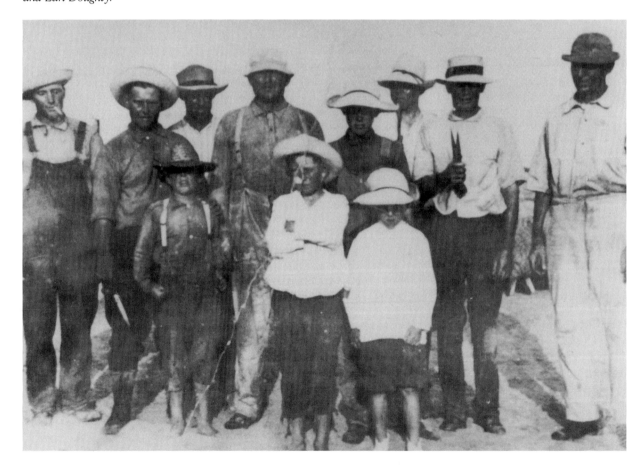

Sud Bell and his banjo were a local legend on Hog Island. Bell provided entertainment at the Red Onion, the local gathering spot on Hog Island, and is the subject of numerous colorful island tales.

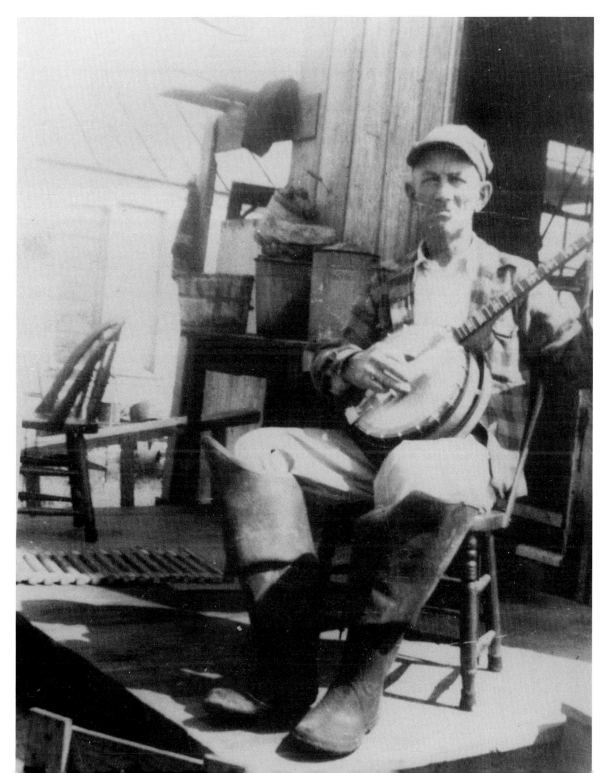

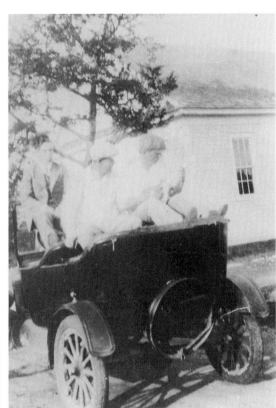

A Broadwater resident strums his mandolin in the back seat of a Model-T.

Two young Hog Island women out for a drive in an island version of a pickup truck, circa 1920.

Soft sand was a common danger for motorists on Hog Island, where there were no paved roads.

Mrs. Ella Mae Melvin feeding her chickens at her home on Hog Island.

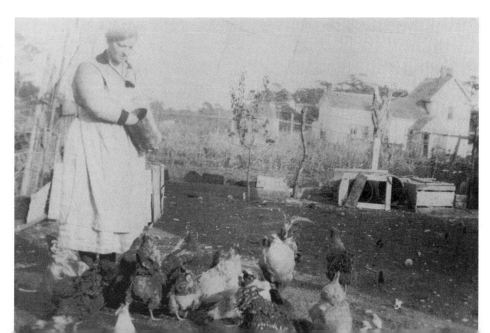

John Melvin, fourth from left, and friends at Broadwater. The occasion was unknown, but a toast was in the making. The man on the left is filling Melvin's glass, as the others smile for the photographer.

Capt. George Doughty, keeper of the Hog Island lighthouse, hunts shorebirds with his rig of wooden decoys, circa 1890.

George Avery Melvin, right, and Harry Bowen pose with their catch after a day of fishing in Broadwater Bay.

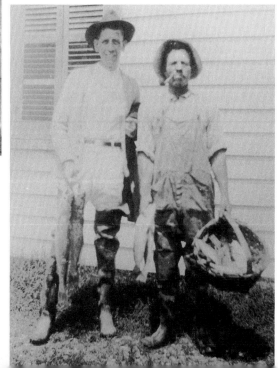

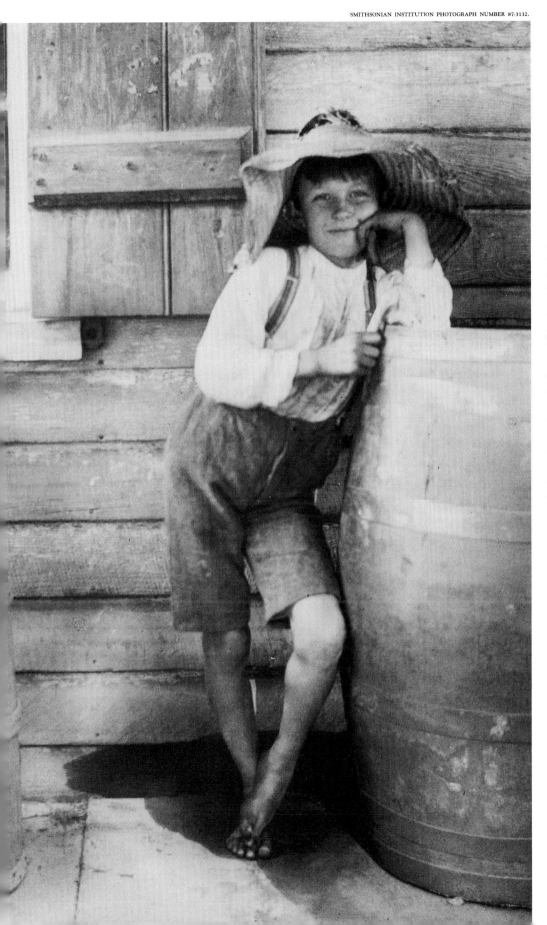

Rudolph Eckemeyer (1862–1932) was a well-known New York photographer who spent much time on Hog Island, making portraits of local people and photographing the island landscape. The Eckemeyer portraits here are from a collection of his work presented to the Smithsonian Institution by Mrs. Eckemeyer following the death of her husband. They were taken in 1902. In this photograph, Eckemeyer posed a young boy with a barrel.

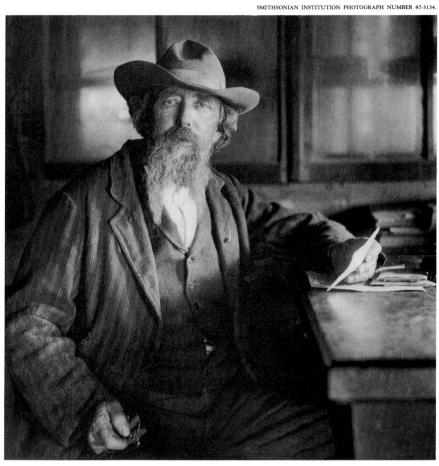

Tom Doughty, a store-keeper on Hog Island in 1902. A few letters are on the desk to the right of the subject.

Three Hog Island boys try out their handmade toy sailboats in a small creek.

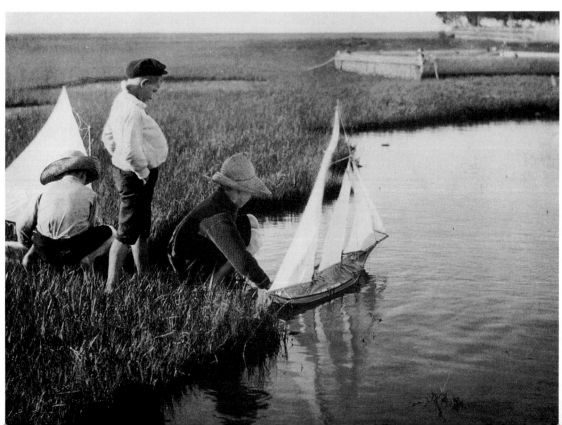

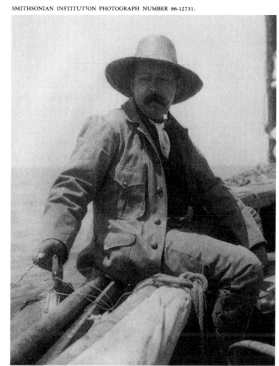

A Hog Island fisherman hand-lines from his sail-boat.

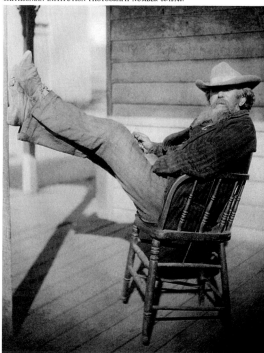

Tom Doughty in a more relaxed pose.

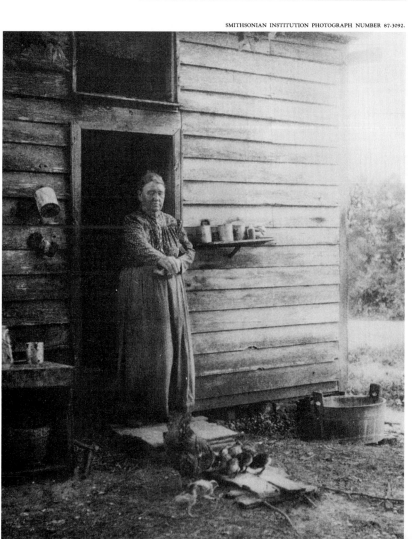

A Broadwater housewife feeds her chickens in this Eckemeyer photograph.

SMITHSONIAN INSTITUTION PHOTOGRAPH NUMBER 87-6893.

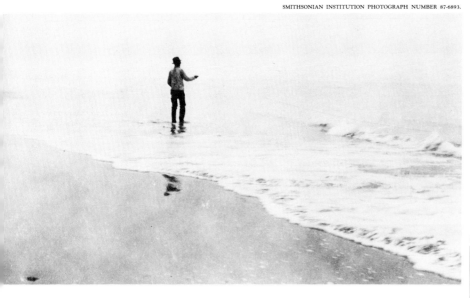

Surf fishing also was done with a hand line. The bait and sinker were tossed into an offshore slough, where drum, trout, and other fish were plentiful.

SMITHSONIAN INSTITUTION PHOTOGRAPH NUMBER 87-3103.

Before the days of rods and reels, fishermen used a thick line to play and catch fish, as this man is doing.

SMITHSONIAN INSTITUTION PHOTOGRAPH NUMBER 87-3101.

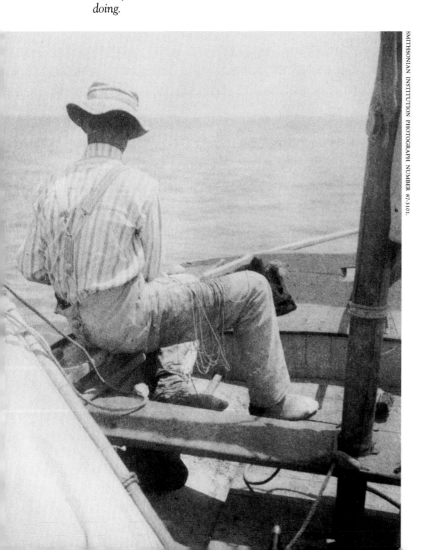

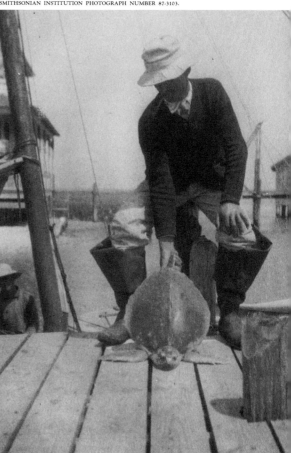

A Broadwater fisherman with a now-endangered Ridley turtle. At the turn of the century the Ridley was prized for its flavorful meat and eggs. The old Hog Island Hotel is to the extreme left.

SMITHSONIAN INSTITUTION PHOTOGRAPH NUMBER 87-6895.

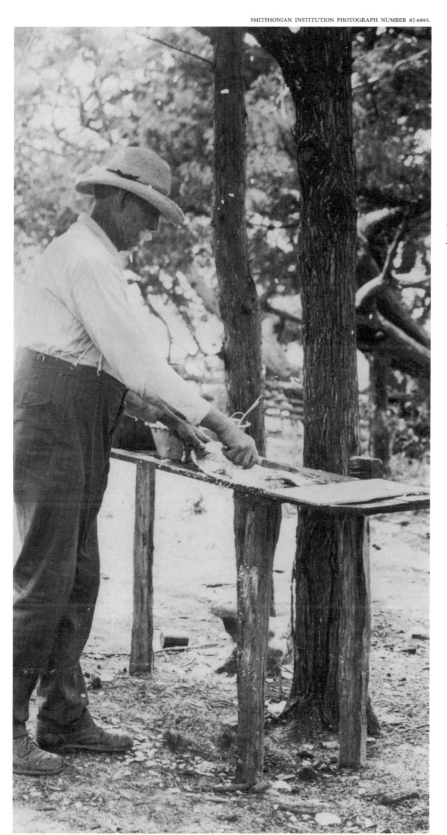

Capt. George Doughty cleaning his day's catch of fish under a cedar tree.

Two Broadwater boys pose in a doorway for Eckemeyer's camera in 1902.

SMITHSONIAN INSTITUTION PHOTOGRAPH NUMBER 87-6896.

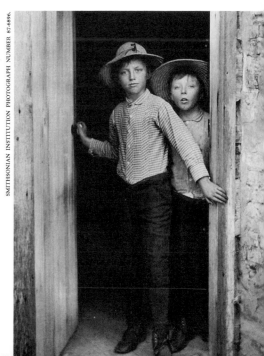

SMITHSONIAN INSTITUTION PHOTOGRAPH NUMBER 87-3135.

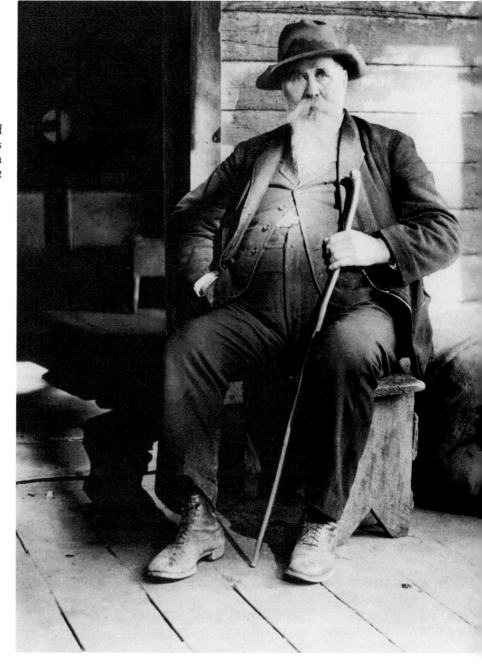

This stately, unidentified gentleman posed with his cane for Eckemeyer on a Hog Island storefront porch.

SMITHSONIAN INSTITUTION PHOTOGRAPH NUMBER 87-3118.

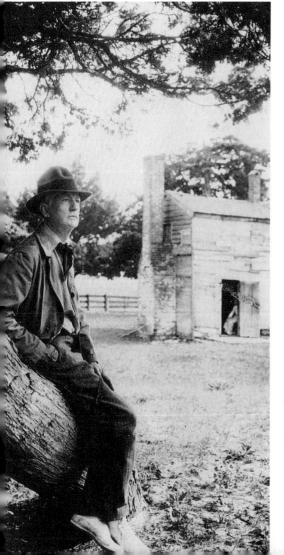

Unidentified gentleman poses beneath a cedar on Hog Island, while a woman watches from the doorway of the home in the background.

*Mrs. Simpson was photo-
graphed by Eckemeyer as
she combed flax.*

SMITHSONIAN INSTITUTION PHOTOGRAPH NUMBER 87-3124.

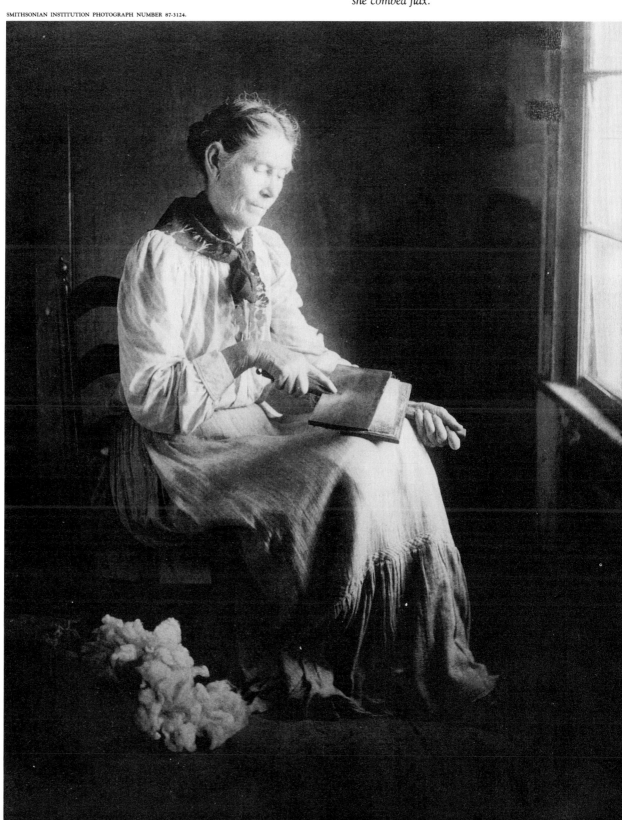

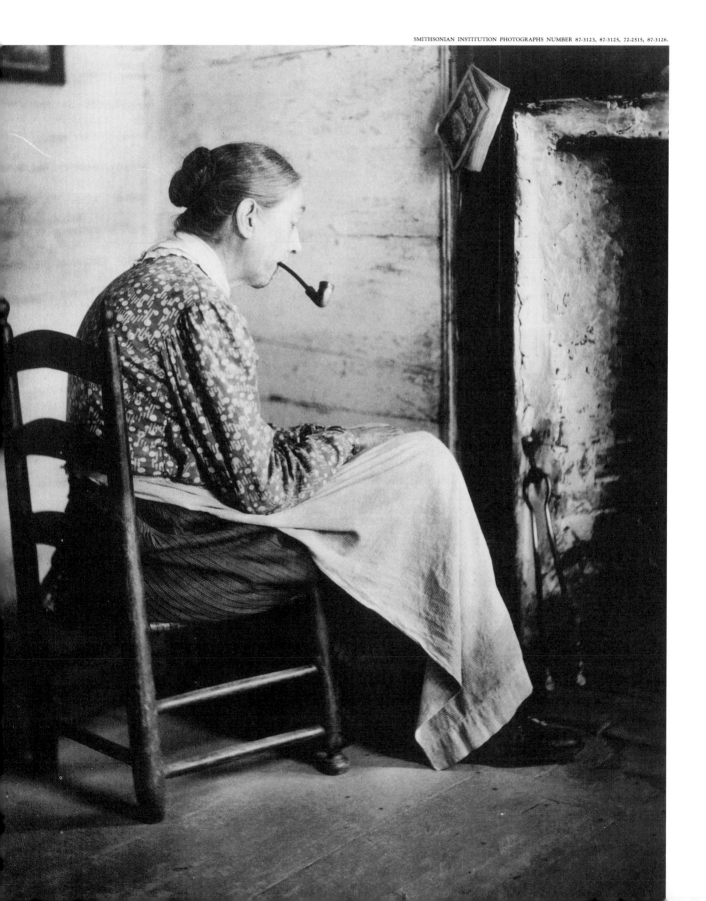

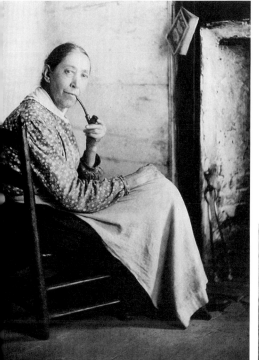

Miss Sallie Doughty, George Doughty's sister, was photographed by Eckemeyer in her Broadwater home as she worked on her spinning wheel by the fire. Miss Doughty relaxed with a little tobacco in her clay pipe. An almanac hangs beneath the mantel of the fireplace.

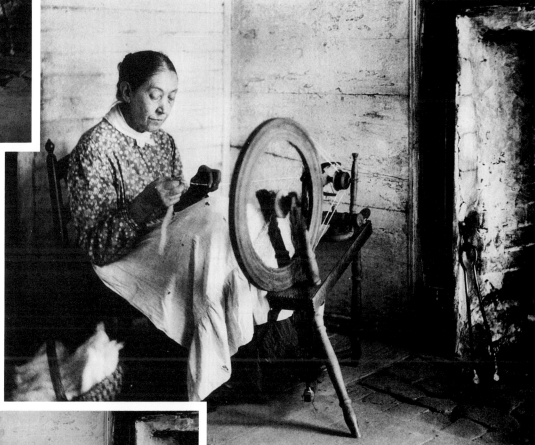

SMITHSONIAN INSTITUTION PHOTOGRAPH NUMBERS 86-12963 and 86-12964.

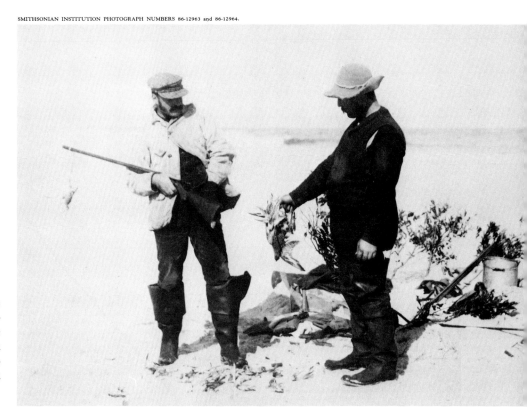

Eckemeyer posed this hunter and guide following a shorebird hunt. The bay myrtle branches on the right were used to make a blind. The ocean is in the background.

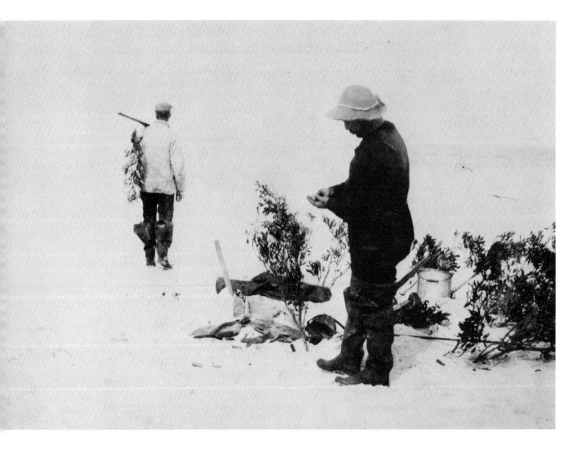

Capt. George Doughty
with his horse and wagon,
in front of the original
Hog Island lighthouse.

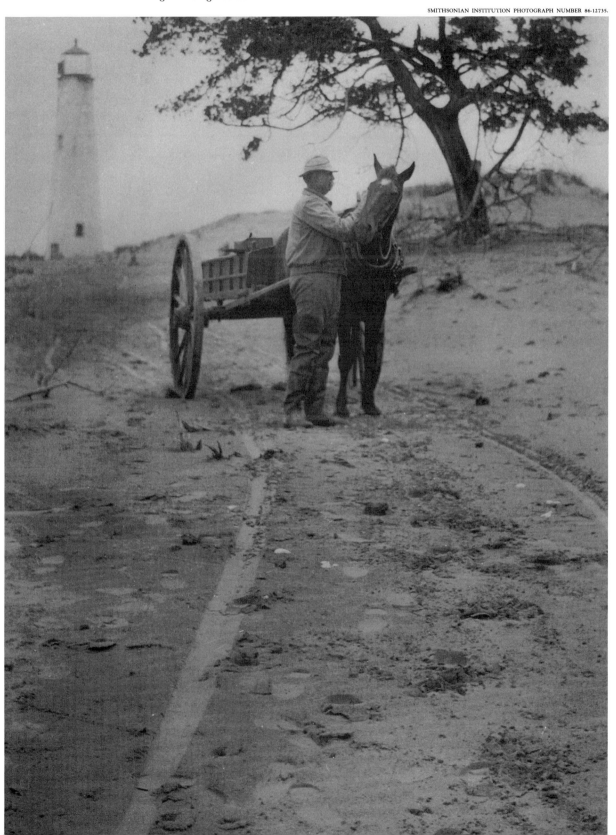

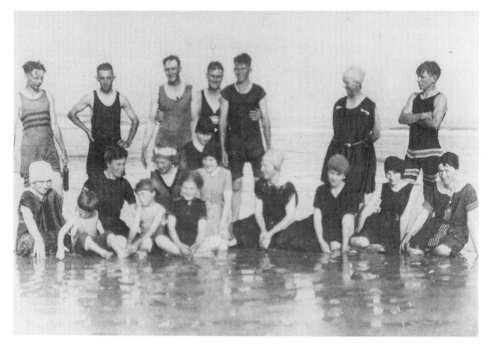

Bathers in the Hog Island surf in the early 1900s.

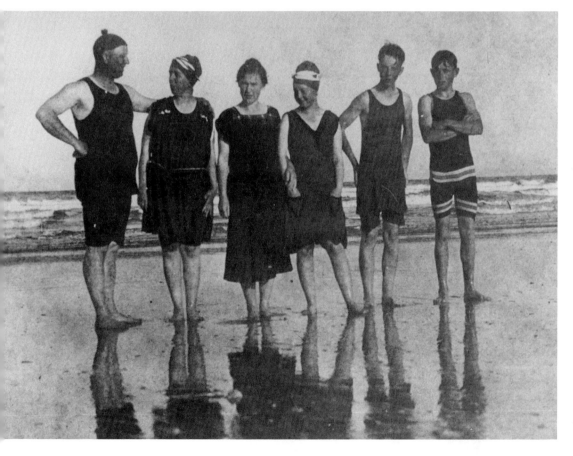

A Broadwater family relaxes at the beach, circa 1910.

Allen Carpenter served on Hog Island with the U.S. Lifesaving Service, the forerunner of the U.S. Coast Guard.

The firm, flat beach at Hog Island made a good landing strip for this vintage biplane in the 1920s.

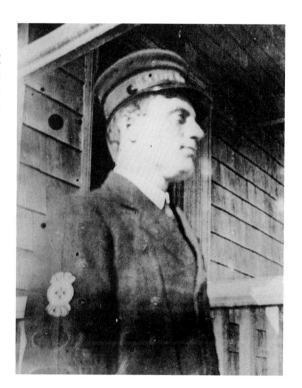

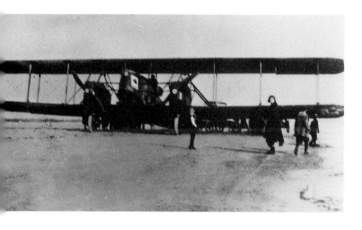

The Hog Island Hotel was built on the south end of the island in 1898 and was partially burned in 1912. The remainder of the building was dismantled.

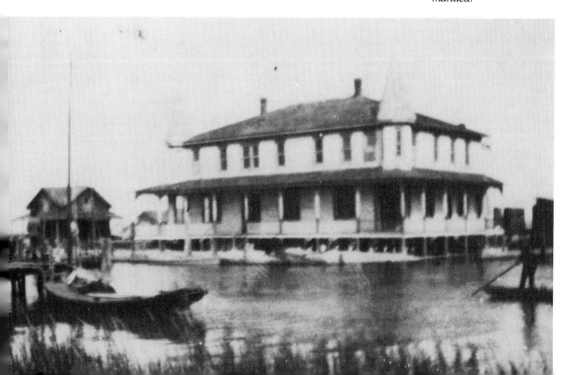

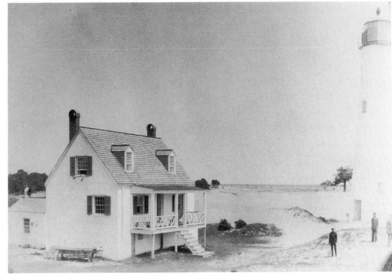

The original lighthouse on Hog Island and keeper's dwelling. This brick facility was built in 1852 and was in service until a new, steel lighthouse was erected in 1896. The lighthouse site is now under the Atlantic.

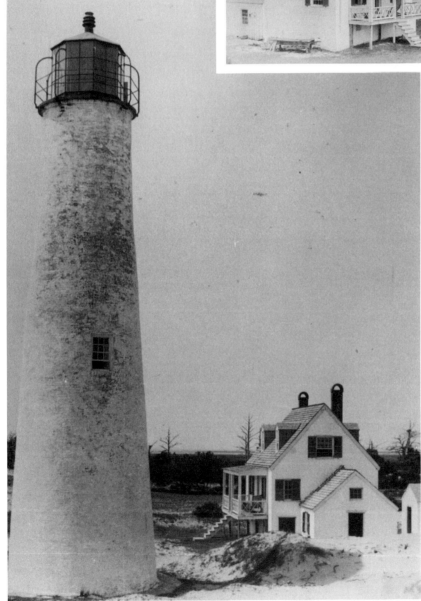

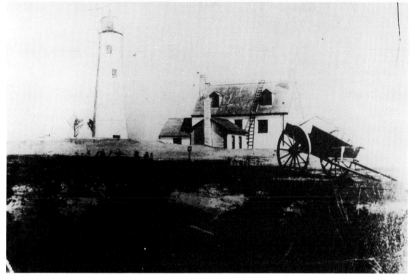

The original lighthouse and keeper's dwelling. A small skiff is in the creek in the foreground.

The original Hog Island lighthouse after decommissioning. The effects of the encroaching ocean can be seen in the cedar tree trunk in the foreground. The island at this time was eroding at an alarming rate.

SMITHSONIAN INSTITUTION PHOTOGRAPH NUMBER 87-3131.

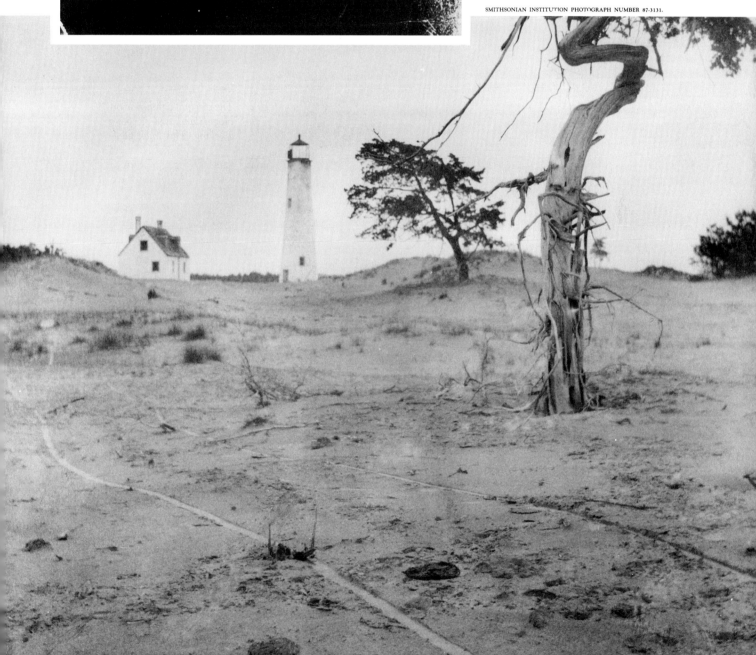

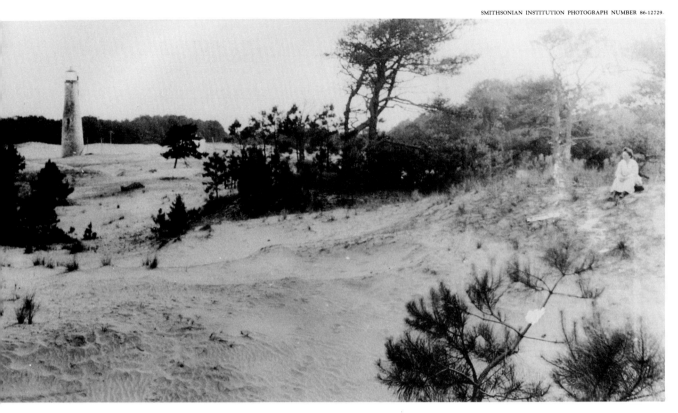

A woman relaxes on a sand dune, right, with the abandoned lighthouse in the background.

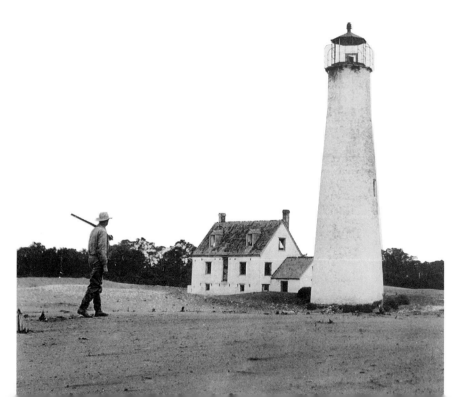

Capt. George Doughty walks past the lighthouse on his way to a hunt.

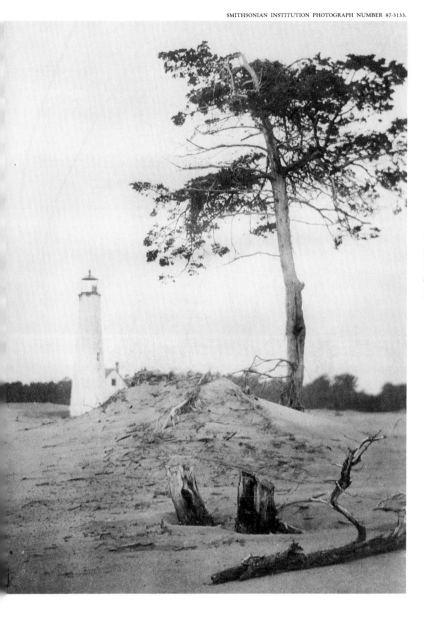

By the turn of the century, the ocean was growing nearer the old lighthouse site. Note the driftwood deposited by high tides.

Buggy tracks lead past the old light and keeper's house.

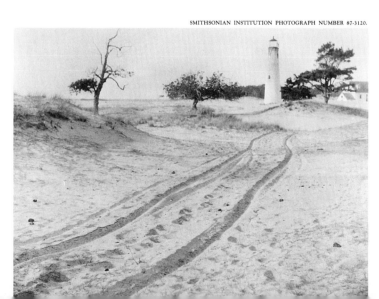

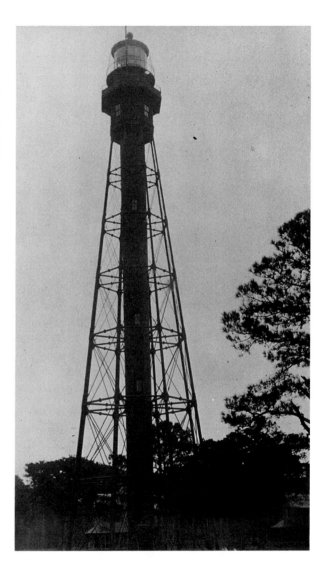

The steel Hog Island lighthouse was built in 1896 and was last lighted in March 1948. It was torn down in 1950, and the foundation is now under the ocean.

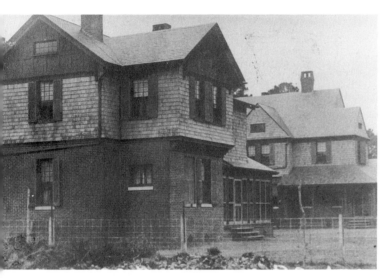

The keeper's dwellings that accompanied the 1896 lighthouse on Hog Island. These dwellings were dismantled and reconstructed on the mainland in the 1930s.

The 1896 lighthouse with service buildings and keeper's residence.

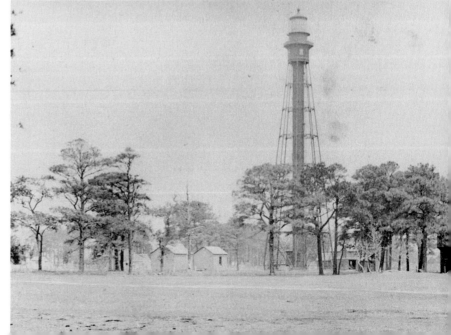

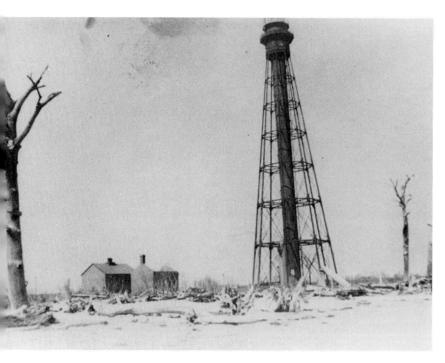

The 1896 lighthouse after decomissioning, around 1949.

An encroaching ocean began claiming the station in the 1930s, and in this photograph surf pounds the building's foundation.

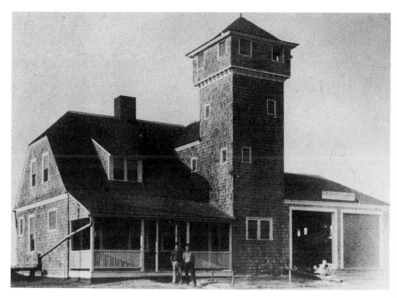

This lifesaving station was built on the south end of Hog Island in 1876 and later served as a U.S. Coast Guard station.

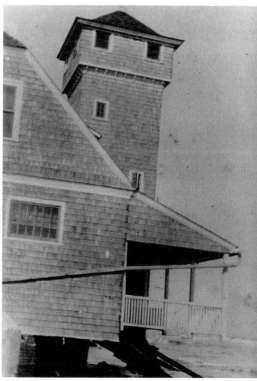

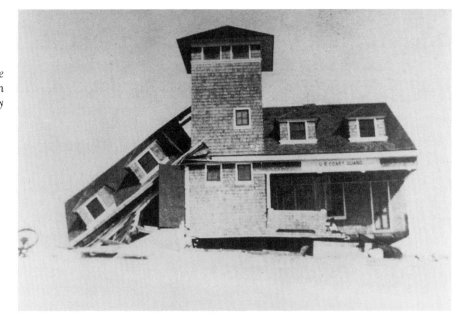

Partially collapsed, the old Coast Guard station was nearly destroyed by the end of the 1930s.

The first Coast Guard station on the north end of Hog Island was this large frame building on Little Machipongo Inlet, now known as Quinby Inlet.

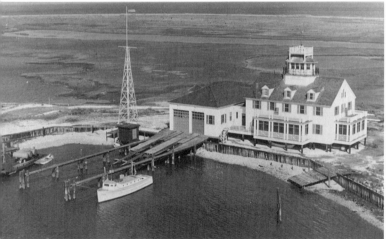

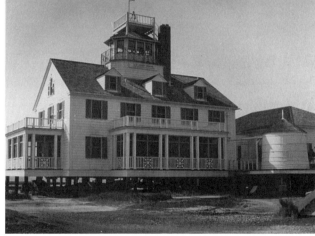

The back view of the Little Machipongo Inlet station. This station was built in the architectural style common to many Barrier Island stations of the period.

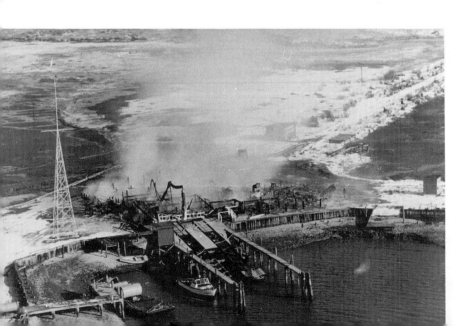

The Little Machipongo station burned around 1952 when a fire started in the furnace room.

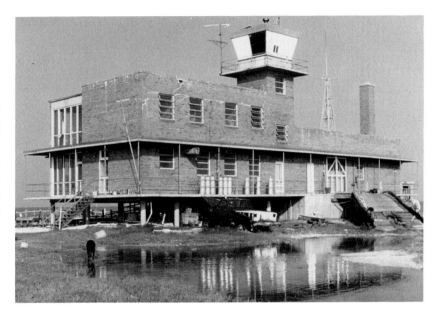

This brick building replaced the burned Little Machipongo station but was decommissioned shortly after construction. The building was used as a private hunting club for a number of years and is now owned by The Nature Conservancy.

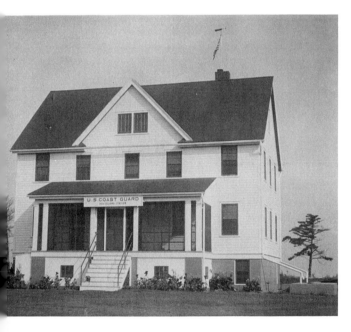

The station on the south end of Hog Island shortly after it was built in the mid-1930s. The photo was taken in 1935.

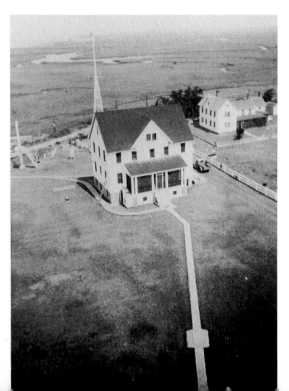

The Coast Guard station as seen from the tower.

An aerial view of the station on the south end after it had been decommissioned.

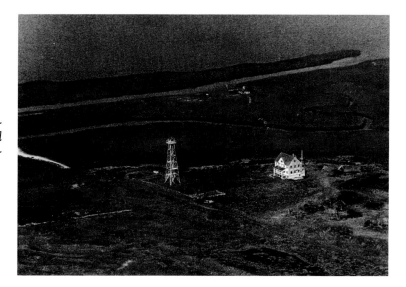

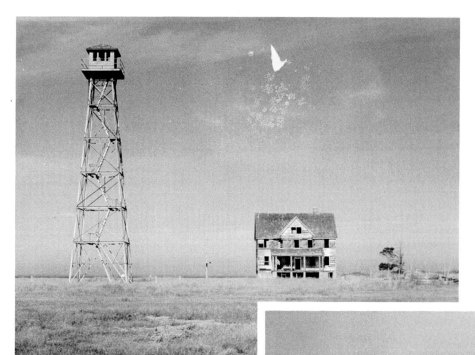

The Hog Island station around 1980.

A fire accidentally destroyed the abandoned station in 1987.

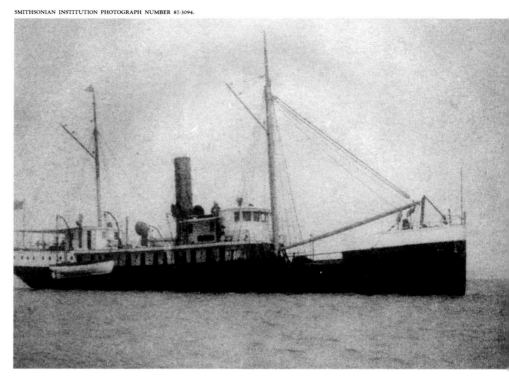

A Coast Guard buoy tender at anchor in Hog Island Bay at the turn of the century.

The crew of the buoy tender rows ashore to visit the community at Broadwater.

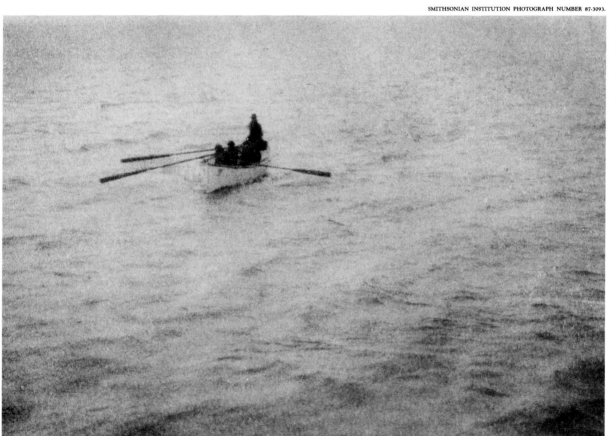

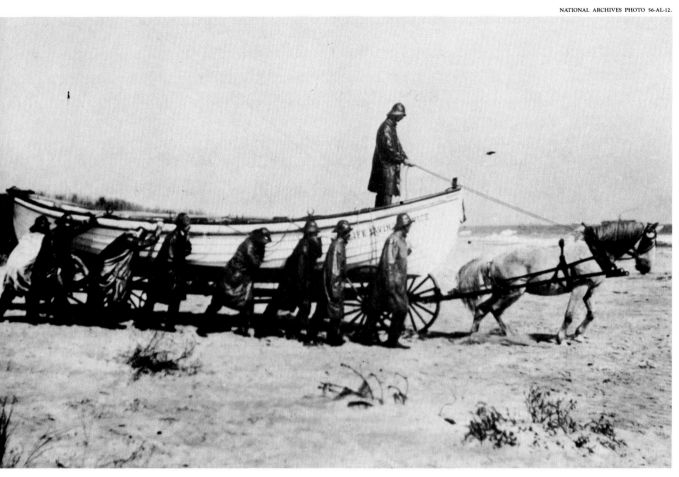

A lifesaving service surf cart with lifeboat is ready for launching in a drill on one of the barrier islands around 1890.

The breeches buoy drill at a Coast Guard station. The buoy and pulley system was used to remove the crew from ships that had foundered on island shoals.

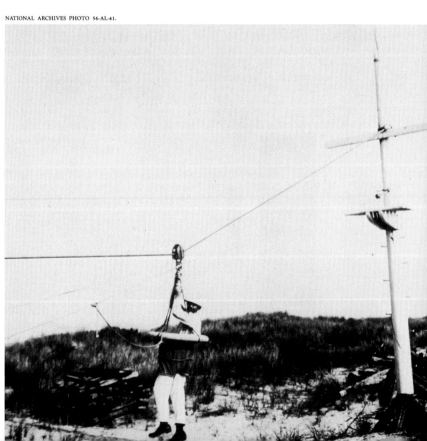

Lifesavers bury a ship-wrecked sailor on a barrier island.

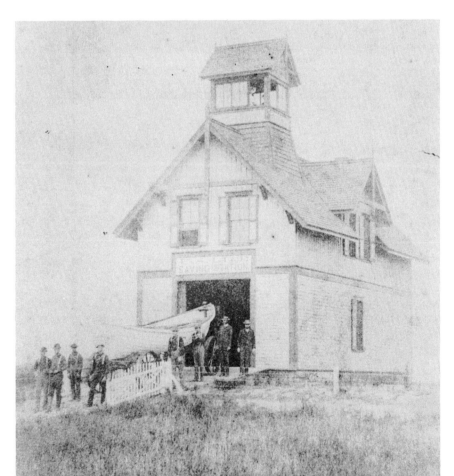

Crew members with a surf boat at a barrier island lifesaving station in the 1880s.

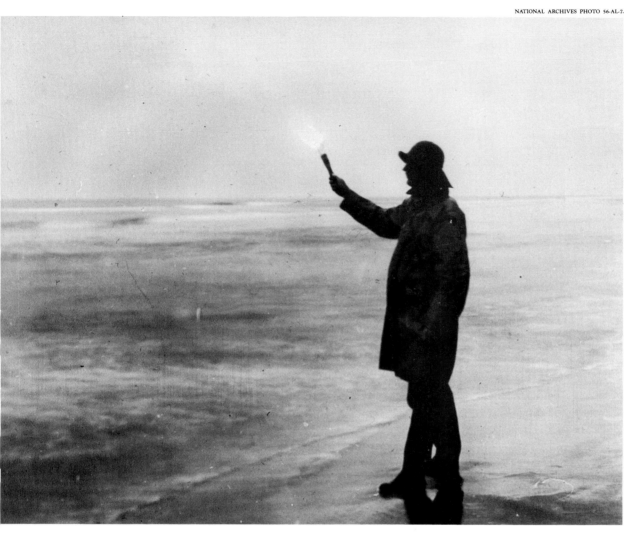

A Lifesaving Service member burns a Coston flare to warn ships away from barrier island shoals.

3
SMITH ISLAND

The Southern Light

Smith is the southernmost of the Virginia barrier islands, and it was the first to be settled by Europeans. Captain John Smith, for whom the island is named, landed there in 1608 and was taken with the "great store of fish, both shel-fish and other."

Smith Island was a very remote barrier beach, but it was essential in the survival of Virginia's faltering colony at Jamestown. Sir Samuel Argoll visited Smith Island in 1613 and reasoned that the salt pools on the island might easily produce this precious preservative for the struggling colony. So in June of the following year, the Jamestown colony sent one Lieutenant Craddock with a detachment of twenty men to mine salt on Smith Island.

The seawater was boiled in huge pots, and the salt precipitate was sent back to Jamestown to preserve pork, venison, fish, and other meats. Salt quite literally could determine the survival of the colony. Without it, food would spoil, leaving the men vulnerable to starvation and disease. With it, the winter of 1614 would not look quite so bleak.

The Jamestown colony mined salt on Smith Island until 1621, according to Jennings C. Wise, who wrote extensively about early Northampton County in his 1911 work, *The Early History of the Eastern Shore of Virginia.*

According to Wise, Smith Island was over the years used as a shipping depot and as a hideout for pirates. Tobacco was stored there in the 1650s, and in the 1680s the island was extensively used by pirates, including Edward Teach, the legendary Blackbeard. In the 1690s the local militia patrolled the Smith Island area, but the island's remoteness made it a popular hideout for outlaws. Wise said that it was common for pirate bands to

anchor off Smith Island in the late 1600s and to send men ashore to kill hogs and gather other food supplies.

Unlike Cobb and Hog Islands, Smith seems to have appealed more to transients than to those seeking to establish roots. Cobb Island had its hotel and famous guests, Hog Island had its village of Broadwater, but Smith's only permanent residents were its lighthouses and lifesaving stations.

Smith Island's Cape Charles Lighthouse was approved by Congress in 1828 at a cost of $7,398, according to local historian Nora Miller Turman. It was completed some four years later, thus beginning a tradition of navigational aid that has lasted for more than a century and a half. In 1874 Congress approved lifesaving stations for the Virginia coast, and facilities were built at Smith, Cobb, Hog, Cedar, and Assateague Islands. Four years later stations were approved for Popes Island, Wallops, Metompkin, and Parramore.

Over the years, Smith Island has played an important military role. Its location north of the Virginia Capes provides an excellent sentry point for monitoring the entry to the Chesapeake Bay. From the American Revolution through World War II, soldiers were assigned to Smith for this purpose.

But Smith's most colorful military role came during the days of the lifesaving station, when the brave men who were stationed there frequently risked their lives to aid sailors who had ventured too close to the dangerous shoals that lined the island.

The Smith Island lighthouse in the 1880s. The original lighthouse on the island was a wooden structure, and was replaced by this brick tower in 1872 at a cost of $7,398.

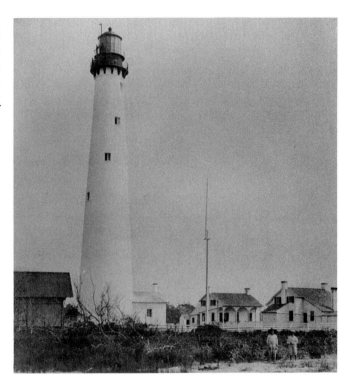

The Smith Island light, probably in the late 1880s. The lifesaving station crew poses with a surf boat beneath the light. Notice how erosion is beginning to claim the station site. Much of the vegetation in the earlier photograph has disappeared. This station was replaced in 1892 by a metal frame lighthouse.

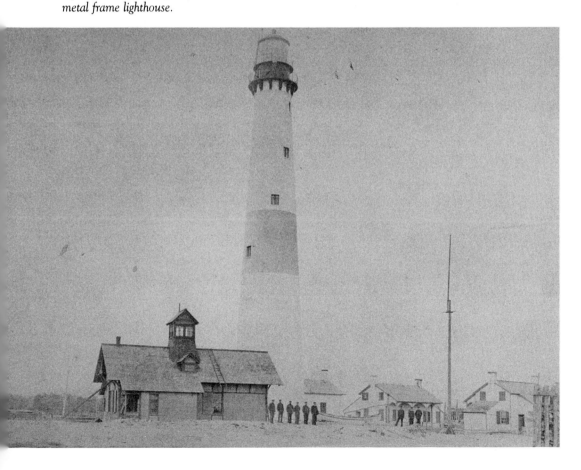

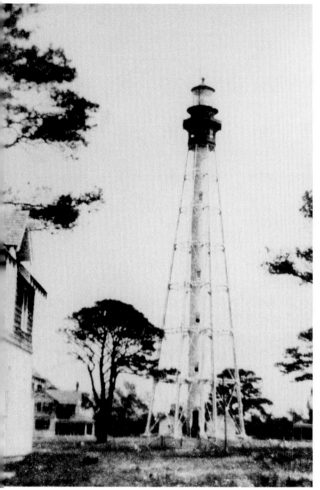

The Smith Island lighthouse and keeper's dwelling photographed in 1933. This light tower was placed in service in 1892.

The Smith Island lighthouse keeper's dwelling in 1931.

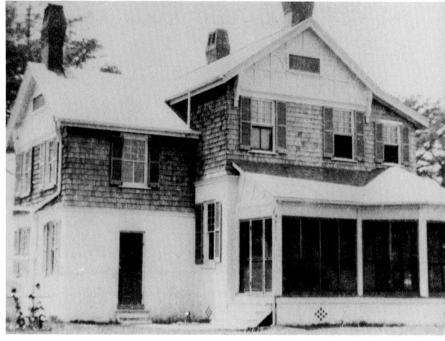

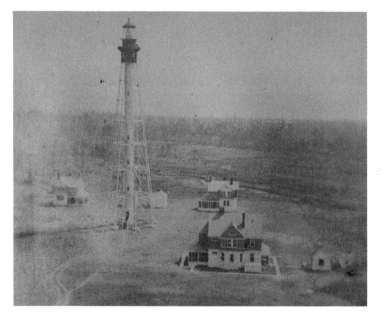

The Smith Island light in another 1933 photograph, taken after the island was flooded by the 1933 storm. Most of the keeper's dwellings shown here are no longer on the island.

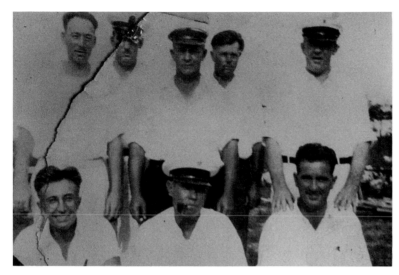

Smith Island crew in 1935.

A lookout tower on Smith Island fell in September 18, 1935. The 1892 lighthouse is in the background.

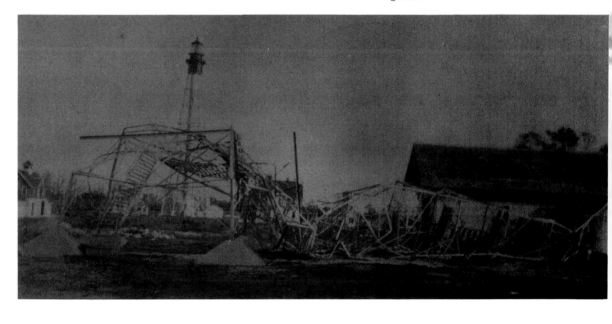

A Smith Island crew member.

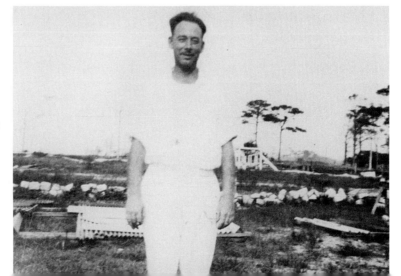

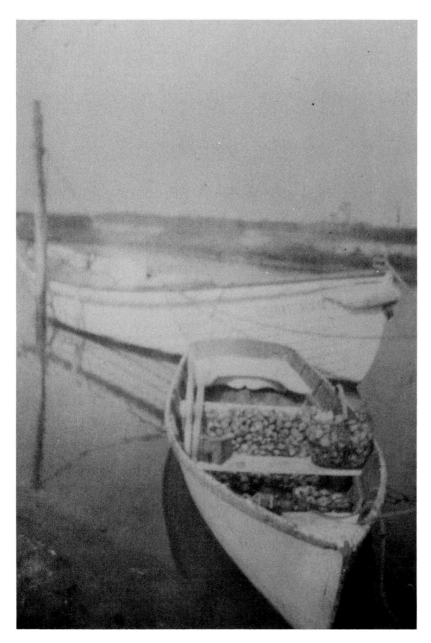

The surf boat on Smith Island loaded with clams caught by off-duty crew members.

4

Accomack Islands

The Village on Assateague, Vacationing on Cedar and Parramore

Today, Virginia's best known barrier island is Assateague, a narrow barrier beach that extends from the Tom's Hook area near Chincoteague northward along the Virginia and Maryland coast to the inlet at Ocean City. Assateague is to the 1980s what Cobb Island was to the 1880s; it is a place of wild beauty that attracts vacationers from all over the world.

Assateague's beach is preserved as a national seashore and the island's interior is protected by its inclusion in the Chincoteague National Wildlife Refuge. The wildlife refuge was begun in 1945, but it was not until a causeway linking Assateague and adjacent Chincoteague opened in the 1960s that the island began receiving nationwide attention. In the two decades since the opening of the causeway, Chincoteague has emerged as one of Virginia's top tourist attractions, and Assateague draws more than 1,000,000 visitors each year.

It's difficult to believe that just a generation ago, Chincoteague was a working watermen's village. Now, motels, restaurants, and gift shops have supplanted the fish houses, and the tourism industry is on its way to replacing the seafood industry. The traditional July Pony Penning celebration, which once was simply a local summer ritual, now attracts network news coverage.

Despite Assateague's current popularity among vacationers, the island's history is not unlike the dozen other islands that line the Virginia coast. Its first inhabitants were American Indians, probably members of the Nanticoke tribe of southern Maryland. Jennings C. Wise writes in his 1911 book, *The Early History of the Eastern Shore of Virginia*, that the Assateague Indians were more warlike than their confederates in the Powhatan

tribe, and that there are few mentions of them in Accomack and Northampton County records. The Assateagues are mentioned often, however, in Maryland records.

In the 1600s, many of the barrier islands in Accomack County were used for grazing livestock. Assateague was used for that purpose, as was Wallops and Assawoman to the south. A number of families lived on the islands, and on Assateague a village centered around the lifesaving station and the lighthouse, which was built in 1833.

Wallops Island was patented in 1672 by John Wallop, who was Colonel Edmund Scarborough's Surveyor General. Wallop, who laid out the town of Port Scarborough (Onancock), patented much land in the Wattsville–Wallops Neck area in the late 1660s and early 1670s. The island was used primarily for livestock, but the 1800 census did show a population of thirty individuals living on Wallops, representing six families.

World War II brought the most profound changes to the Accomack County islands. The U.S. Coast Guard was heavily involved on the islands during the war, and several islands were used for quarantine purposes and special training. On Assawoman Island, for example, the army established a canine training unit. After the war, the federal government surveyed Wallops; in 1945 it purchased eighty acres from a group of sportsmen and established a rocket launching facility. Four years later the government purchased the remainder of the island, establishing what would become the National Aeronautics and Space Administration Wallops Island facility.

The Coast Guard maintained manned stations on Assateague, Chincoteague, Wallops, Metompkin, Cedar, and Parramore Islands during World War II, but a few years later, all but Chincoteague and Parramore had been decommissioned.

Except for the refuge at Assateague and the NASA facility at Wallops, the islands are virtually undeveloped today. Assawoman is privately owned, and at this writing is proposed to be included in an expanded national wildlife refuge. Most of Metompkin and Parramore Islands are owned by The Nature Conservancy. Although Cedar Island was recently subdivided and lots were sold, the island's vulnerability to erosion makes substantial development impractical and expensive.

As with Cobb and Hog Islands in Northampton County, most of Accomack's islands have seen their glory days of human habitation. Parramore is one of the largest and most beautiful of the islands, and it is protected by The Nature Conservancy in its Virginia Coast Reserve. The island once belonged to Colonel Thomas Parramore, who was elected to the Virginia House of Burgesses in 1748 and whose son helped fight for American independence. A fort on Parramore helped protect the coast from the British during the Revolution. Thomas Parramore gained ownership of the island when he married Joanna Custis Hope, who was an heiress to the land. Today the island has only the abandoned lifesaving station, now privately maintained, and the current U.S. Coast Guard station, the only barrier island station remaining on the Eastern Shore.

All the islands in Accomack have had their share of sporting clubs and

lodges, some of which, like the Accomack Club west of Parramore, were opulent, and some of which were modest. On Cedar Island, the Mears family of Wachapreague operated the Island House Hotel, which they ran in conjunction with their famous Wachapreague Hotel, an impressive white frame building constructed in 1902 and destroyed by fire in 1978. The Island House was not opulent by today's standards, but the fishing and hunting were unparalleled, and the resort drew vacationers from all over the country.

The lifesaving station on Assateague beach in 1919. The crew is practicing a surf rescue procedure using a Lyle gun to project a line over the breakers to a stranded ship.

The Assateague Lifesaving Station in the early 1900s. From left to right, Granville Hogg, Bert Bowden, Lee Mason, John Taylor, Capt. Joe Feddeman, John Kambarn, Joshua Hudson, John Snead, and Selby Andrews.

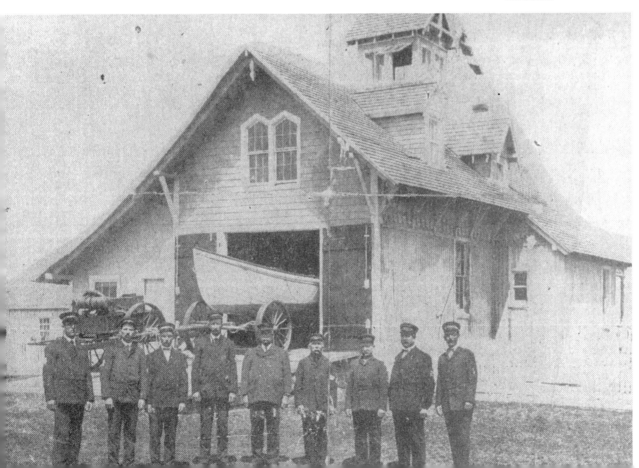

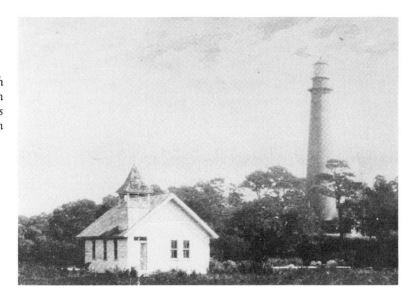

The Assateague church and lighthouse, built in 1833. The lighthouse was converted to electric in 1932 and is still in use.

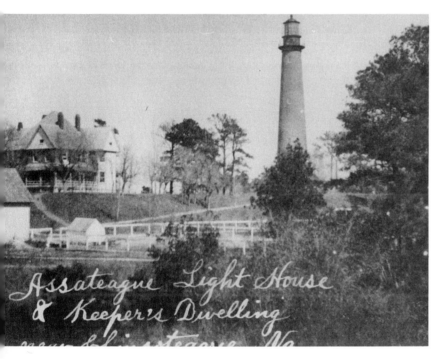

The Assateague light and keeper's dwelling in the early 1900s.

Killock Shoals light between Franklin City and Chincoteague in a photograph taken from the lighthouse service boat circa 1920. Mr. William Collins was the keeper of the light at the time.

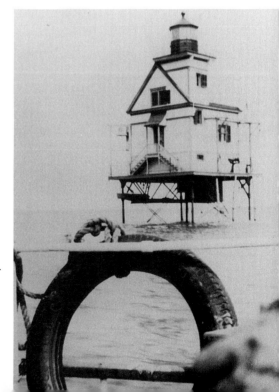

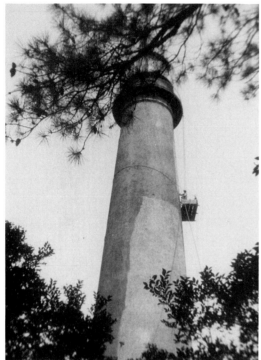

Mr. William Collins painting the Assateague light in 1925.

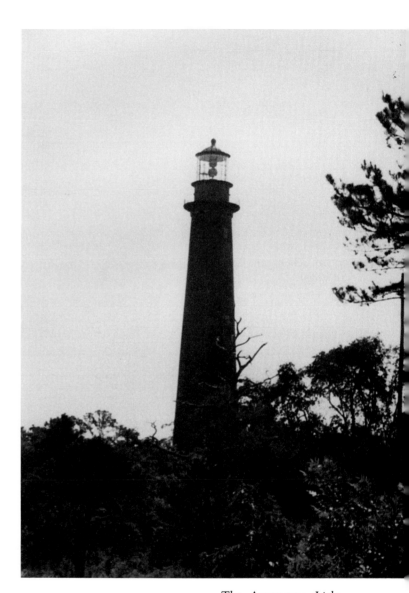

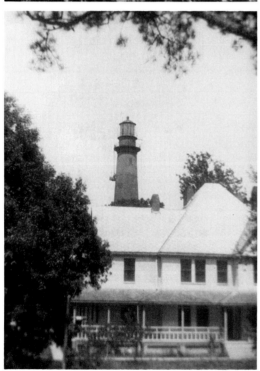

The keeper's dwelling on Assateague with Mr. Collins painting the lighthouse in the background.

The Assateague Lighthouse today is a popular attraction at the Chincoteague National Wildlife Refuge. The refuge was opened to the public when a bridge connecting Assateague and Chincoteague was opened in the 1960s.

This skiff was used to transport school children from Assateague Island to school on Chincoteague.

The village on Assateague in the 1920s. The church is on the right, and the island of Chincoteague is across the channel in the background.

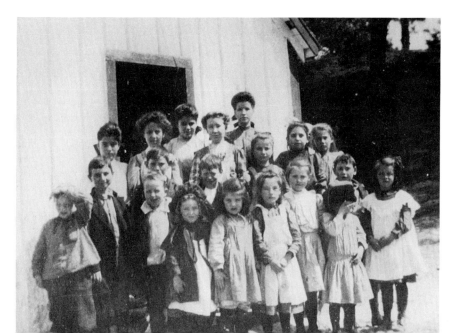

Class picture of the 1906 student group at Assateague school.

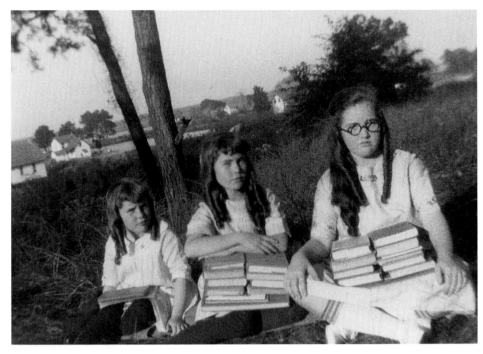

Students on Assateague in the 1920s: from left, Ruth, Margaret, and Ada Collins.

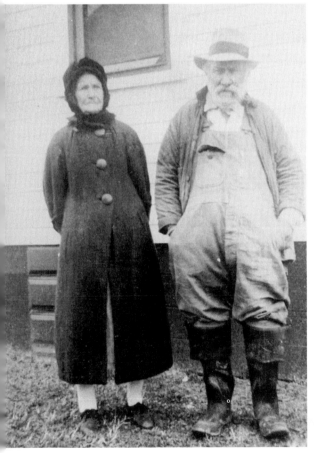

Mr. and Mrs. Bill Scott in the early 1920s at their home on Assateague. The Scotts were among the last persons to live on Assateague.

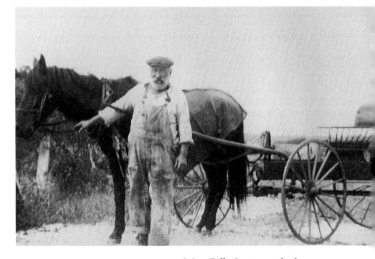

Mr. Bill Scott with his Assateague Island transportation. Mr. Scott, the island's only shopkeeper, used his buggy to deliver fresh vegetables to the residents of the village of Assateague.

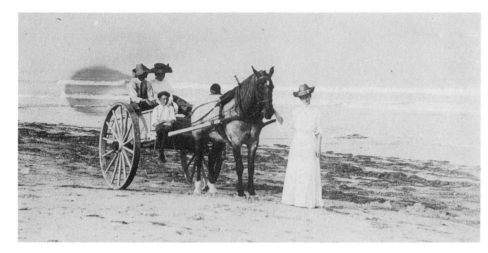

This horse and buggy was a reliable means of beach transportation on Metompkin Island at the turn of the century.

The Wallops Island Clubhouse was a popular gathering spot on the Eastern Shore around 1900, when this picture was taken. The club was used until the 1930s. A NASA facility is currently on the island.

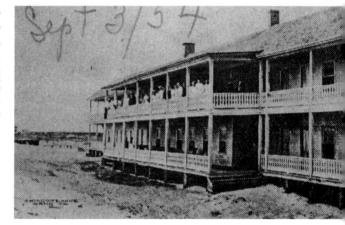

Before the Chincoteague causeway was built in 1922, the only public transportation link with the mainland was by boats such as the Mananzanita, which transported passengers, cargo, and mail between Chincoteague and Franklin City.

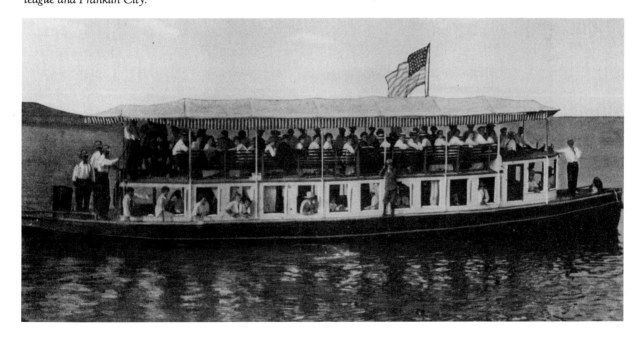

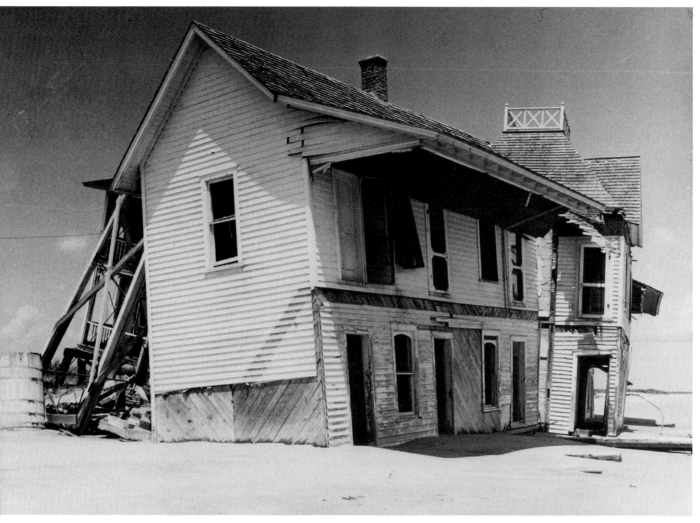

The old Wallops club-
house as it was being
claimed by an encroach-
ing ocean around 1950.

Cedar Island, just south
of Metompkin, was a
popular vacation spot in
the late 1800s and early
1900s. Here, visitors
board a small boat at
Burton's Shore near the
town of Accomac for the
ride across Burton's Bay
to the island.

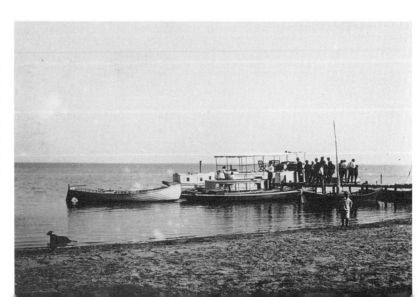

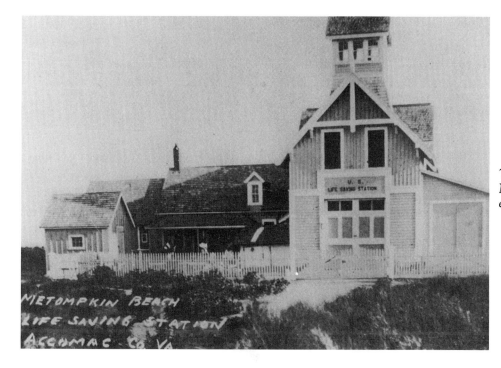

The lifesaving station at Metompkin Island in the early 1900s.

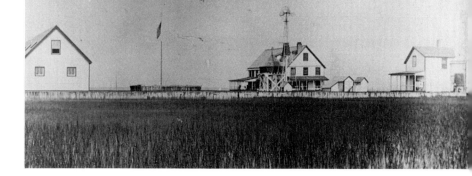

The Coast Guard had abandoned the Metompkin station when this photograph was taken in 1949.

The Accomack Club was incorporated in 1887 and was one of the first sportsmen's clubs on the seaside in Accomack county. The lodge was located on the marsh behind Parramore Island east of Wachapreague.

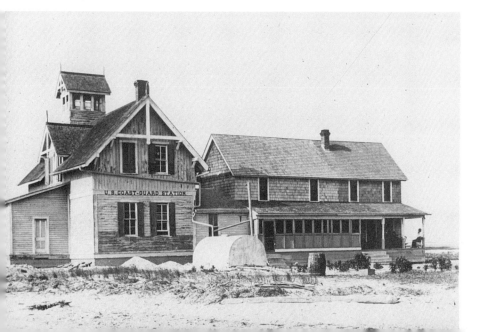

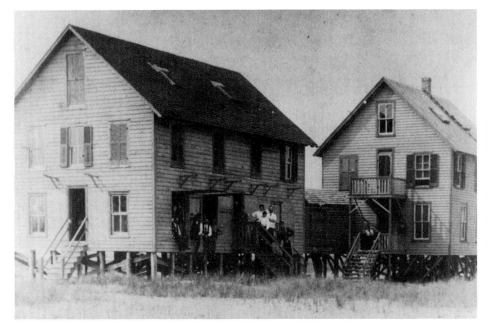

The Island House Hotel on Cedar Island was operated by the A.G.H. Mears family of Wachapreague, owners of the Wachapreague Hotel. The island hotel was not fancy, but it was a favorite of fishermen and hunters from around the country.

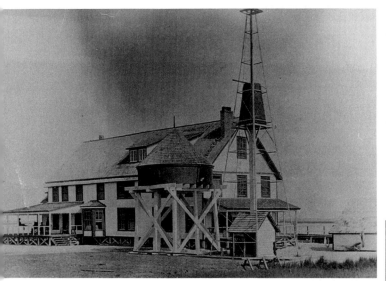

The Accomack Club flourished in the late 1800s and early 1900s, and when the railroad was completed on the Eastern Shore in the 1880s, sportsmen came from all over the East Coast to fish and hunt in the barrier island marshes.

The Accomack Club, with a naptha-powered steam engine skiff docked in front.

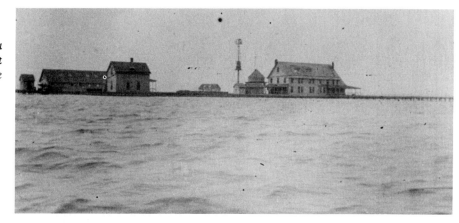

The Accomack Club in a photo taken as a boat approached from the Wachapreague area.

A panoramic view of the Accomack Club, showing the main clubhouse, boat-house, staff quarters, and service buildings.

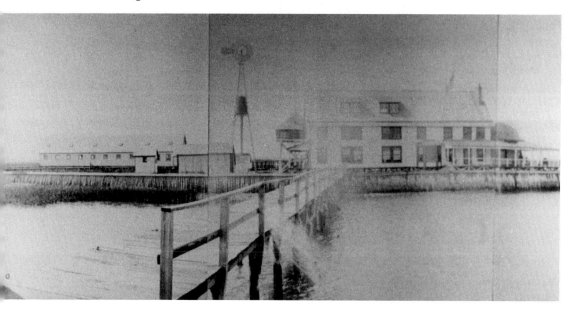

Another view of the Accomack Club around 1900.

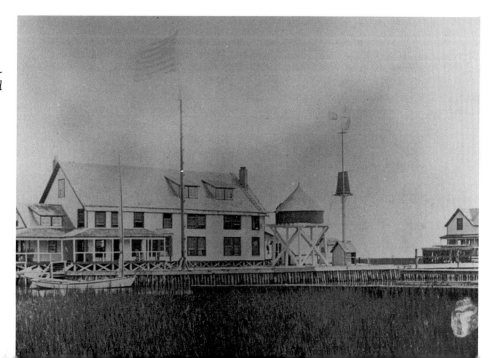

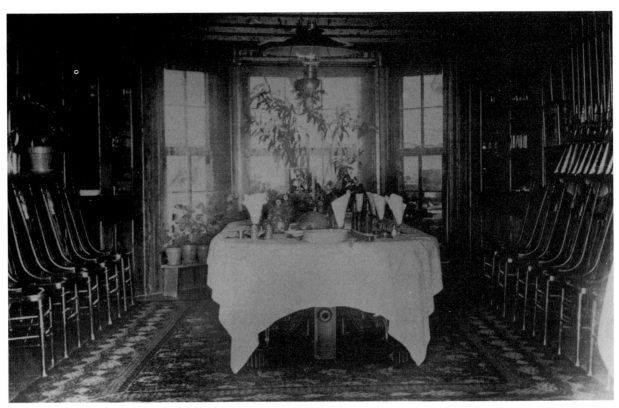

The dining room of the Accomack Club. Note the large ham and the bottles of wine on the table. A gunrack is on the wall on the far right.

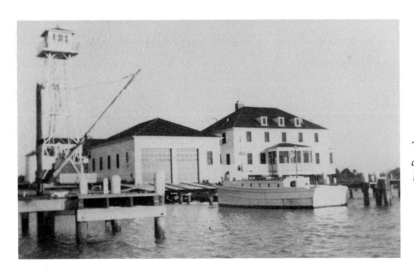

The Coast Guard station at Cedar Island around 1935.

The Cedar Island Coast Guard Station, front view.

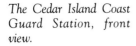

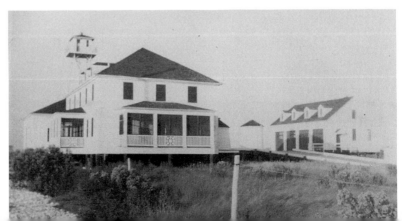

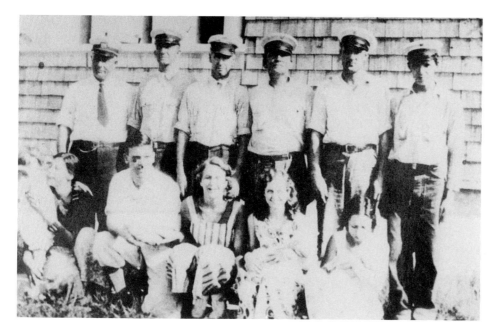

The Coast Guard crew and families on Cedar Island, 1930s.

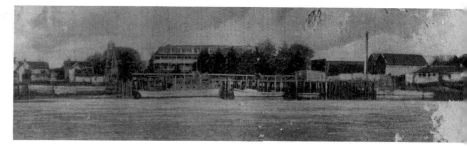

The Wachapreague waterfront was a point of embarkation for Cedar Island, the Accomack Club, and other popular barrier island spots. The Wachapreague Hotel is in the background.

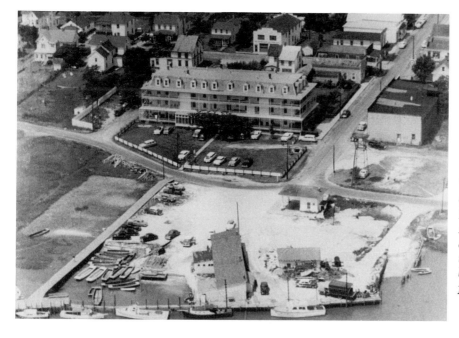

The Wachapreague Hotel was built by A.G.H. Mears in 1902 and served sportsmen and vacationers for three-quarters of a century. The old building was destroyed by fire in July 1978.

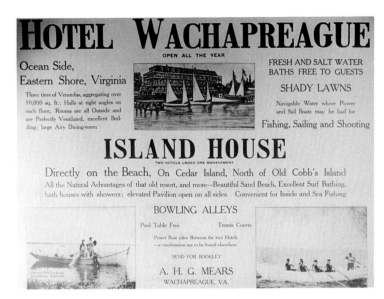

Mr. Mears owned the Island House Hotel on Cedar Island, which complemented his more opulent facility on the mainland at Wachapreague.

Hotel Wachapreague attracted sportsmen from all over the country, advertising unsurpassed spring hunting for snipe and curlew, summer fishing for trout, and fall hunting for ducks, brant, and geese.

FISHING RATES

WACHAPREAGUE GUIDE ASSOCIATION

(ONE TO FOUR PERSONS)

Inside Bottom Fishing	$45.00
Ocean Drift Fishing	$45.00
Drum & Channel Bass	$50.00
Wreck Fishing	$50.00

(OVER FOUR PERSONS $5.00 EACH)

Light Trolling	$75.00
Tuna & Marlin	$85.00

THE ABOVE RATES INCLUDE BAIT AND ICE
(EXCEPT SHEDDER CRABS)
TACKLE FURNISHED FOR TROLLING ONLY
BOTTOM FISHING TACKLE — $1.00 PER ROD & REEL
ALL PARTIES LIMITED TO SIX PASSENGERS
—DEPARTURE TIMES—
TROLLING 6:00 A.M. BOTTOM FISHING 7:00 A.M.
Boats Leave Bottom Fishing Ground At 3:45 P.M.
$8.00 PER HOUR FOR OVERTIME FISHING

A few years ago, a group could spend a day fishing out of Wachapreague for as little as $45.

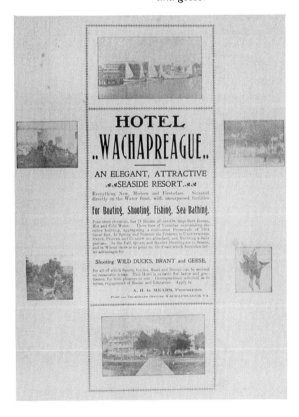

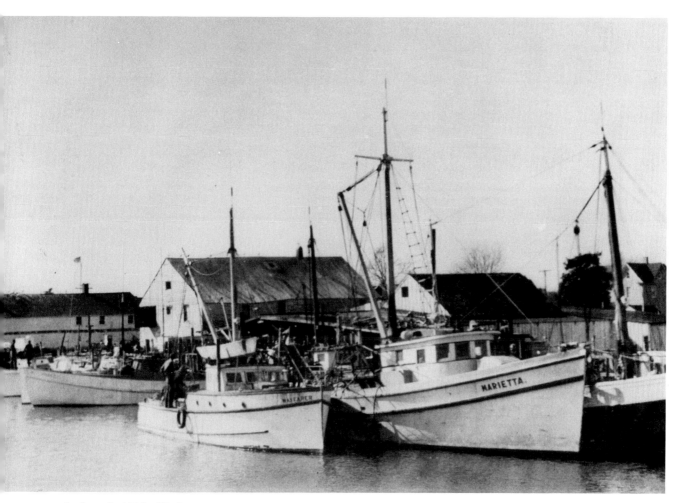

In the early 1900s, Wach-
apreague was a home port
to commercial fishermen
as well as sport fisher-
men. These boats were
part of the port's mackerel
fishing fleet.

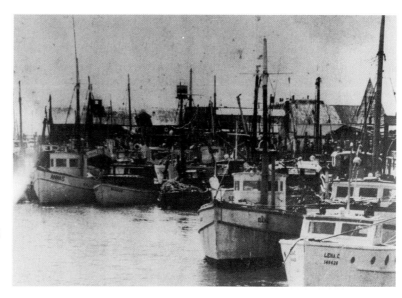

Wachapreague's mackerel
fishing fleet in the 1930s.

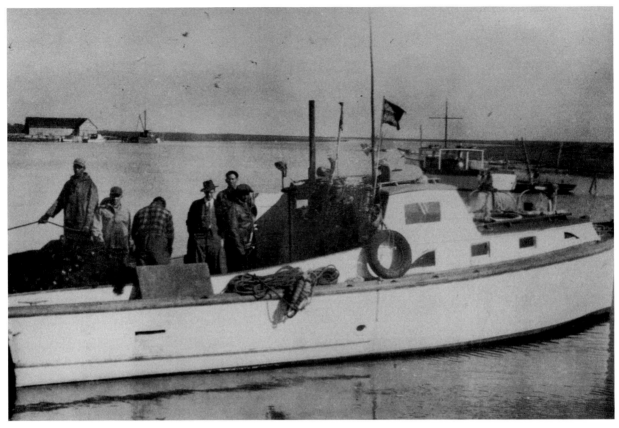

Netters returning to Wachapreague with a day's catch.

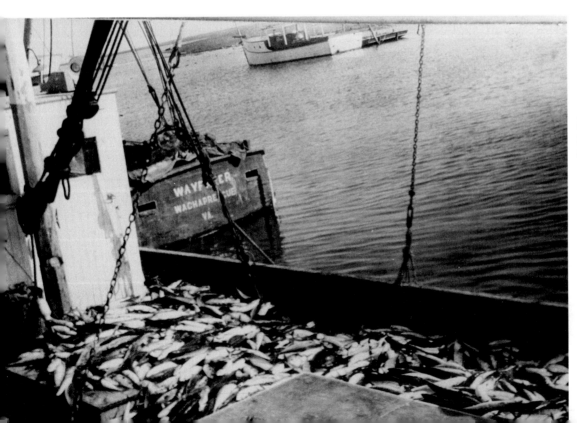

Mackerel await processing at the Wachapreague dock in the 1930s.

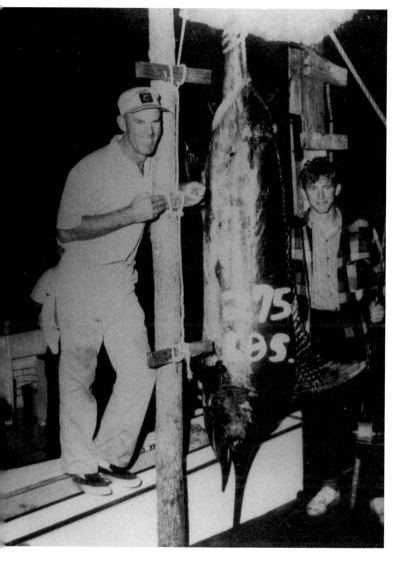

Captain Ray Parker of Wachapreague with the first blue marlin taken out of the seaside port.

An unusual catch on the seaside, a large tarpon taken by Bo Phillips, left, and Snooks Kilmon.

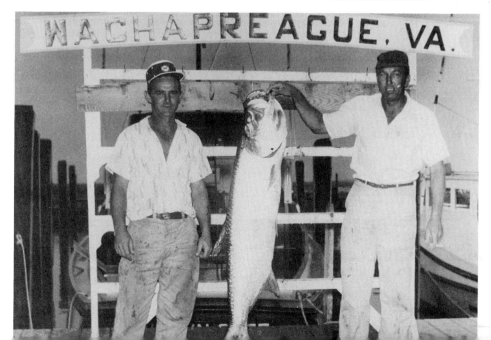

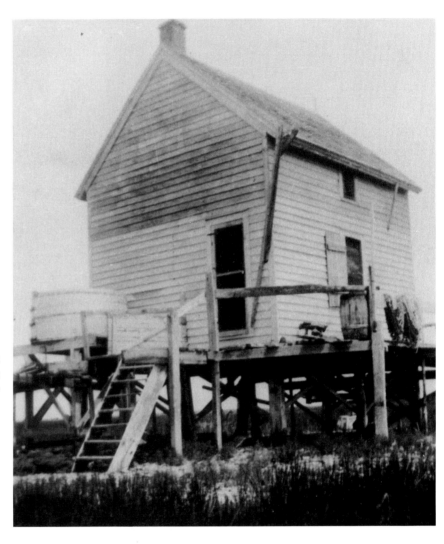

A caretaker's cabin on Revel's Island, behind the southern tip of Parramore.

GEORGE SHIRAS III, © NATIONAL GEOGRAPHIC SOCIETY.

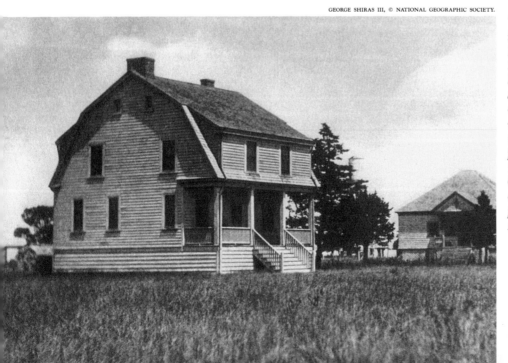

The Revel's Island Shooting Club in early 1900s. Photographer George Shiras III became a member of the club in 1894 and used this cottage, which included a dark-room for developing photographs. In 1898 Shiras published a book, Hunting Wild Life With Camera and Flashlight, which included many photos taken during his stays on Revel's Island.

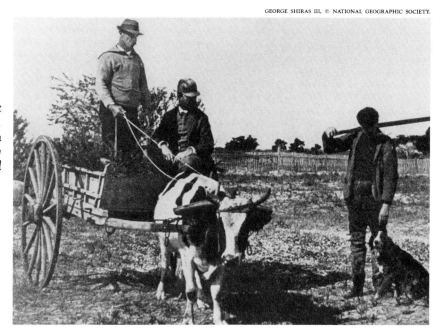

Little Jerry, a dwarf ox, at work on Revel's Island. The buggy is loaded with cedar boughs, probably for making shorebird blinds.

A catboat on Revel's Island with shorebird decoys placed on the marsh, from a Shiras photograph.

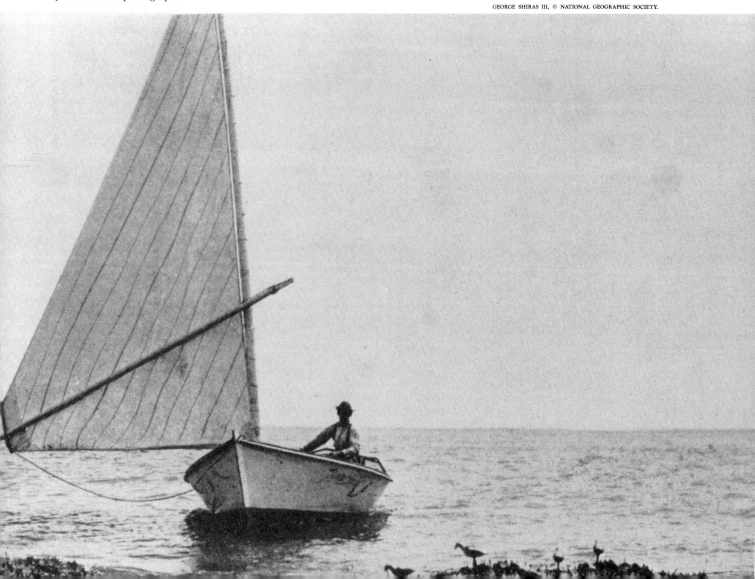

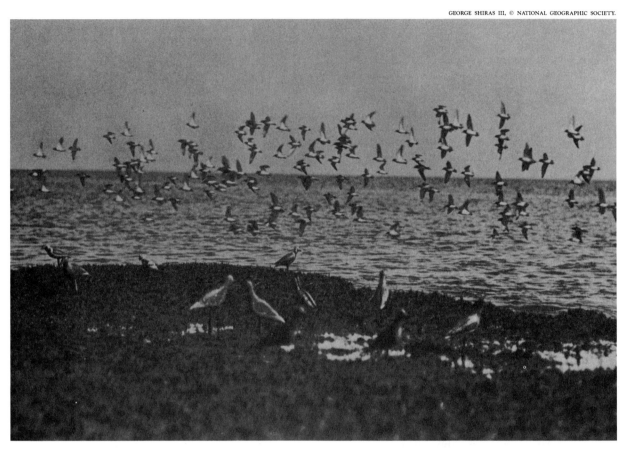

A large flock of pectoral sandpipers photographed on Revel's Island by Shiras. Decoys are placed on the marsh in the foreground.

Decoys entice shorebirds in an early Shiras photograph. The decoys in the foreground are carved from wood, but the ones in the background were made of hinged metal.

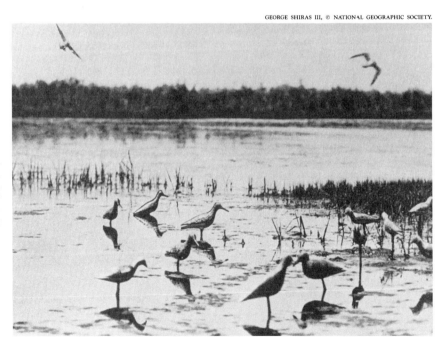

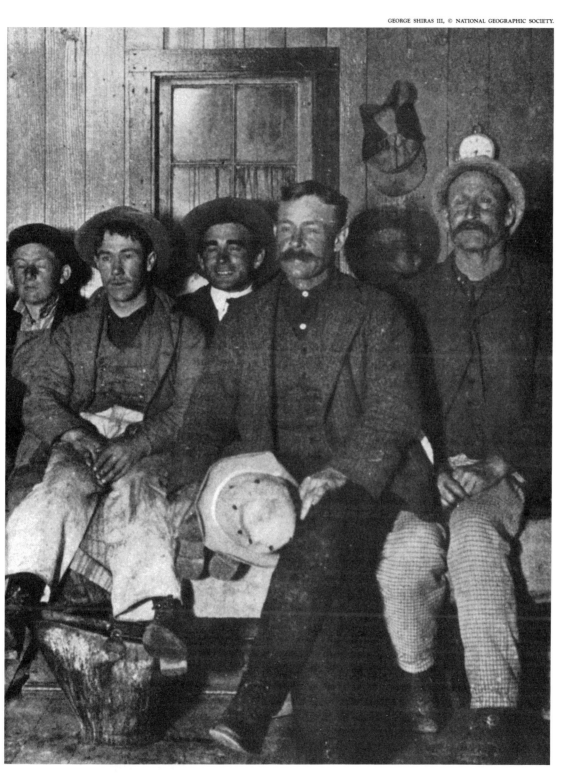

A group of Revel's Island guides photographed by Shiras in 1901.

THE LODGES

Simple and Fancy Sporting Retreats

Beginning with the years of Reconstruction following the Civil War, the Virginia barrier islands saw an increasing amount of recreational use. As the nation healed its wounds and northern cities grew prosperous, business and political leaders sought escape from the industrial grind by retreating to the isolated marshes and islands of the Eastern Shore.

Hotels and clubhouses were built, some of which were quite opulent, and America's leaders came to the islands to fish, to hunt wild game, or simply to relax. The Cobb family hotel on their Northampton County barrier island was one of the most famous, but there were lodges of various sizes on many of the barrier islands, as well as on the inner islands and marshes. Chincoteague and Assateague had several lodges, as did Wallops, Metompkin, and Cedar. The Accomack Club, one of the finest, was built east of Parramore Island. Hog Island had several hotels and hunting lodges, as did Skidmore and Mockhorn Islands.

The leeward marshes had numerous lodges over the years, many of which were private. The accompanying photos show lodges such as Man and Boy, Running Channel, New Inlet, and Walke Inn, which were built not on the barrier beaches, but on the high marshes behind the beach.

Several extensive clubs were built on the inner islands, on land sandwiched between the barrier islands and the mainland. One of the most interesting and long-lived was the compound on Mockhorn Island in Northampton County. A lodge was built by Nathan Cobb, Jr., on Mockhorn in the mid-1800s, which was purchased and enlarged by the Cushman family of New York in the early 1900s. The Cushmans built a concrete sea

wall around the island; added a new, larger lodge, a barn, and several outbuildings; and did extensive landscaping. The Cushmans owned the island until 1948, when they sold it to T.A.D. Jones, a government contractor who entertained military and political leaders there during the years after World War II. Generals would fly in by helicopter for a few days of fishing or hunting, and would be entertained lavishly at the Mockhorn compound, which at that time included a large hall where barn dances were held. Jones kept the island until his death in 1959. Mockhorn is now owned by the state of Virginia, and little remains of the lodges and other buildings that once graced the island.

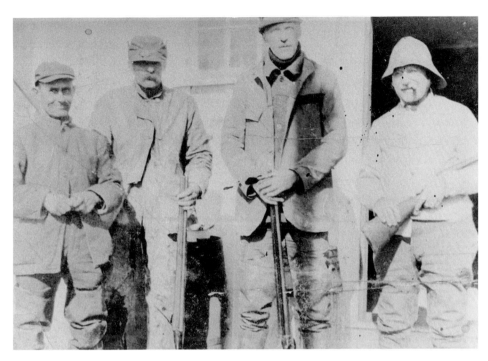

From left, Joe Crumb, George Coates, and two sportsmen at the Man and Boy Channel Gunning Club off Sand Shoal Channel out of Oyster. The picture was taken around 1920.

Joe Crumb putting out shorebird decoys on marsh at Running Channel. The shorebird decoys were carved by the Cobb family. Shorebird hunting was made illegal in 1918.

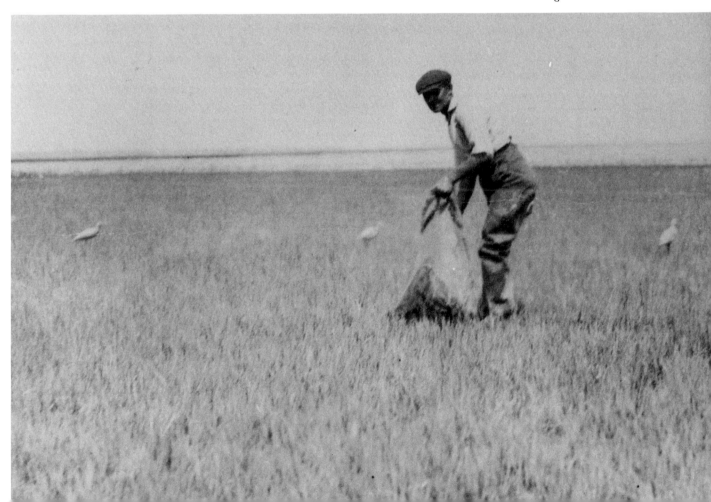

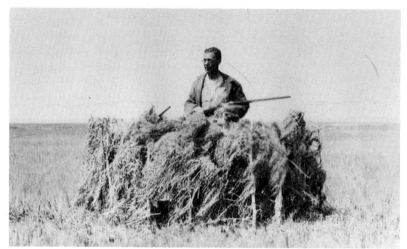

A Running Channel Club guest awaits the morning flight in his shorebird blind.

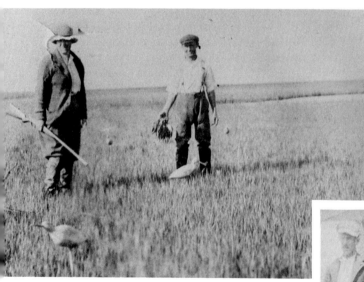

Mary Bell Watts, left, and Joe Crumb pick up shorebirds after a morning hunt at the Running Channel Club around 1920.

At Man and Boy Club following a shorebird hunting trip. Joe Crumb sits with the club's pet black duck and working decoy, Murphy. Also pictured are Tom Morrow, and guides Willie Crumb and Joash Hutchinson, who hold the shorebirds while unidentified hunters pose for the camera.

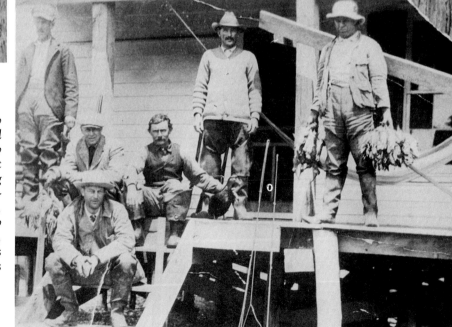

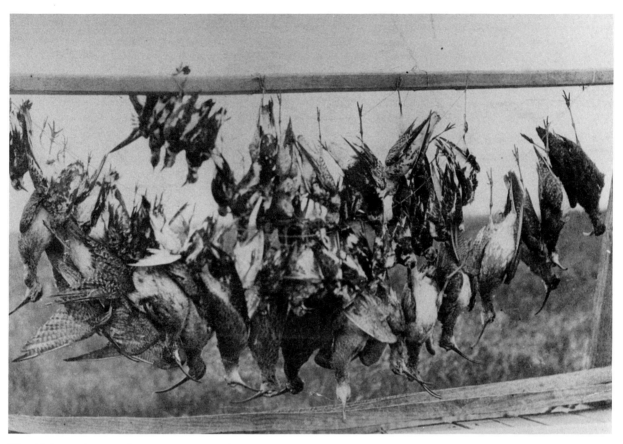

Shorebirds, curlews, and graybacks killed at Man and Boy Club.

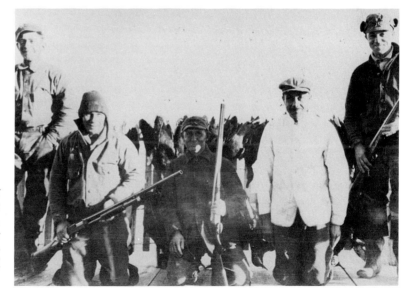

Guides at the Running Channel Club and the kill of the day. From left, Paul Lafferty, Oscar Crumb, Joe Crumb, Sanford Sisco, the cook, and George Etz.

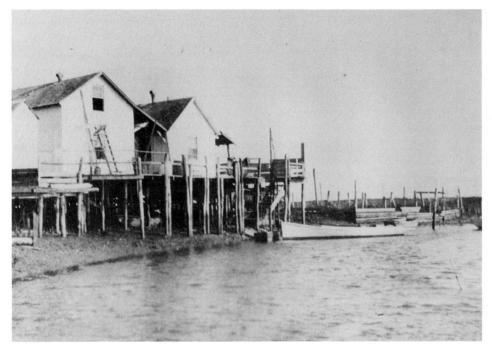

The clubhouse at Running Channel, owned by Joe Crumb.

Joe Crumb used a striking iron to catch this red drum on the flats in South Bay in 1905.

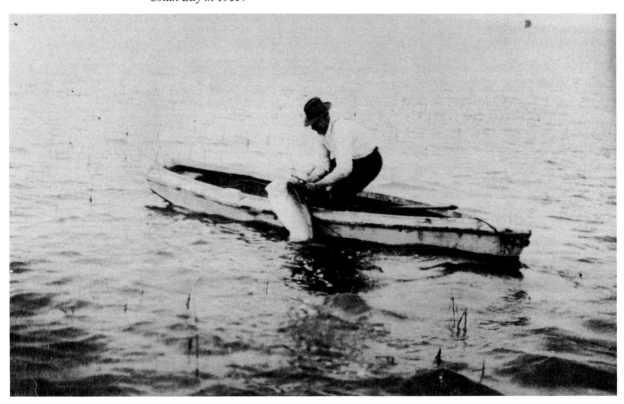

Joe Crumb with black ducks taken in a morning hunt. When these photos were taken in the 1920s, limits were generous and conservation measures were just going into effect. For numerous reasons, the black duck population has declined over the years, and today the limit is one per hunter per day.

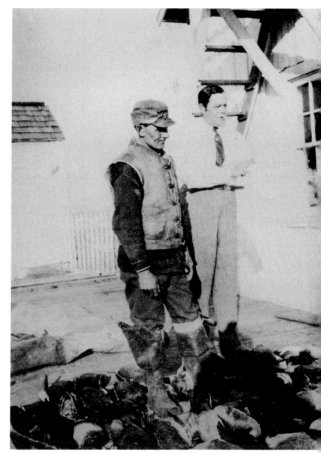

Joe Crumb and black ducks killed during an outing at Running Channel Club in the 1920s.

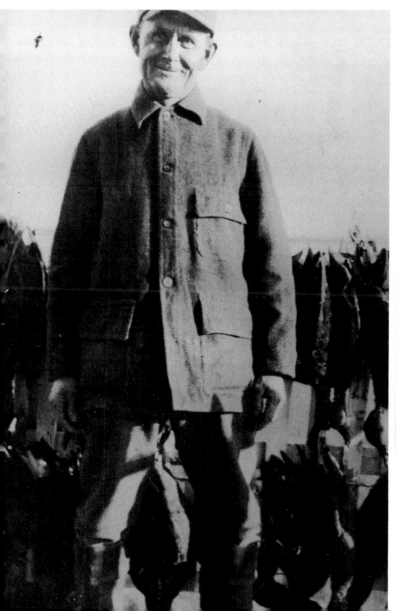

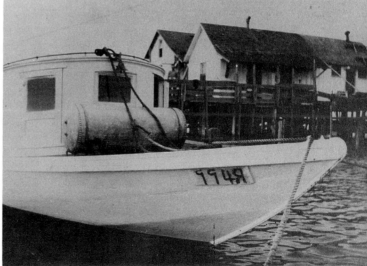

Joe Crumb's boat Annie May, photographed on July 21, 1921 at Running Channel Club.

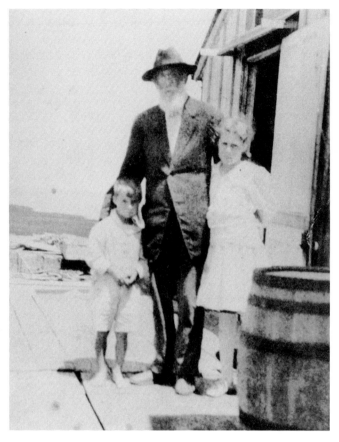

Willie Crumb, left, Charles Crumb, and Eunice Crumb posed in front of the lodge at Man and Boy Club in 1918.

Joe Crumb with a large red drum.

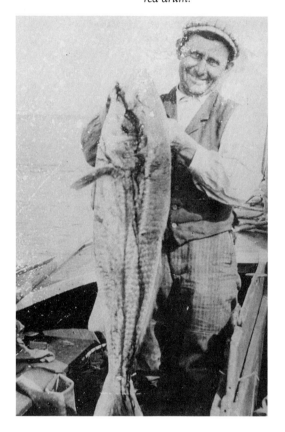

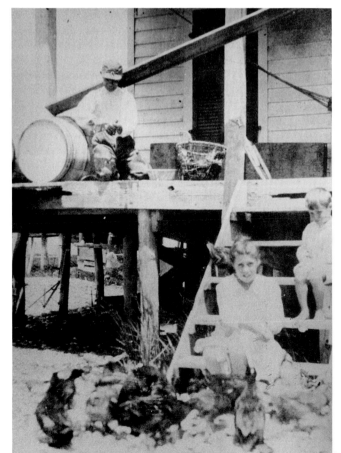

Joe Crumb, top, Willie Crumb and Eunice Crumb shuck oysters at Man and Boy Club. Murphy the black duck is standing on the steps. Murphy was used by hunters to toll in wild ducks; when the ducks got within gun range, Murphy would retreat to a safe spot, says Eunice Crumb Glaxner, daughter of Joe Crumb.

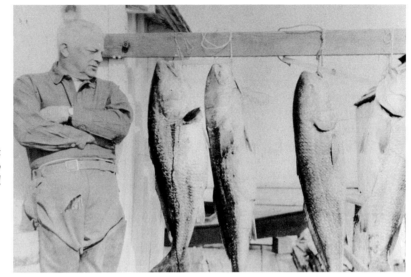

A sportsman fishing out of Man and Boy Club poses with a catch of red drum.

Joe Crumb and party surf fishing on Cobb Island in 1926.

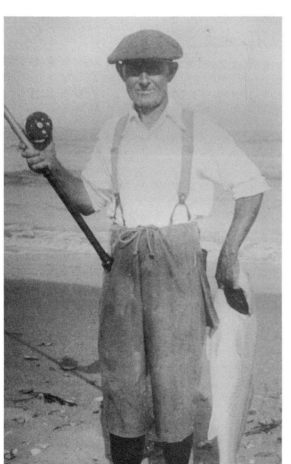

Joe Crumb surf fishing on Cobb Island in 1930, holding a red drum.

The Cardwell Lodge and George West, Jr.

Drum caught in the Cobb Island surf by Joe Crumb's Running Channel Club party.

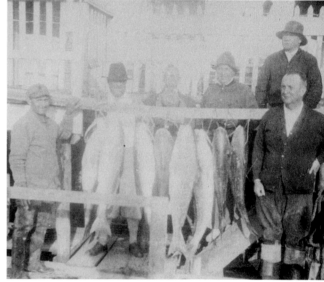

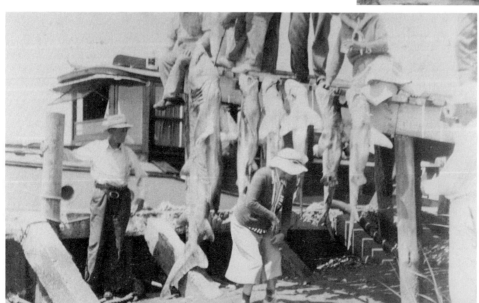

Shark-fishing party out of Cardwell Lodge in the early 1930s.

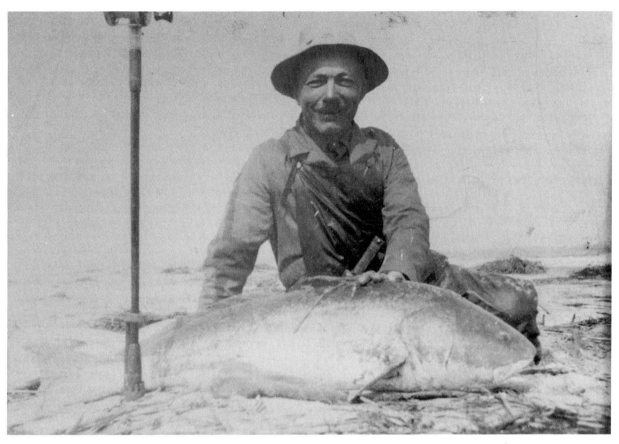

Fred Benze with a 38-pound red drum caught while surf fishing on Cobb Island.

The first fishing lodge on Little Cobb (also known as Cardwell) Island. The island is on the southern tip of Cobb Island, and the lodge was built by the W.D. Cardwell family of Richmond. Pictured are, from left, Lawrence West, George West, Jr., Mrs. Jim Taylor, and Mrs. George West, Sr.

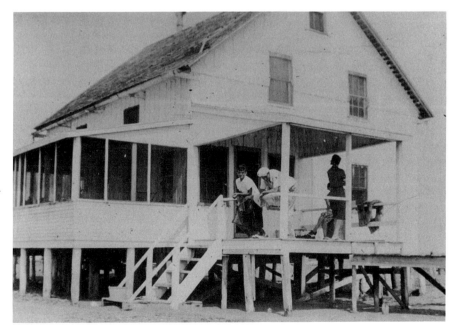

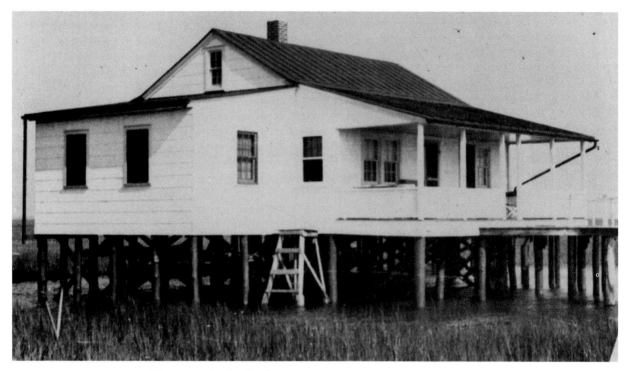

The second Cardwell Lodge on Little Cobb, built by B.W. Davis of Richmond in 1947. This building is still being used as a private lodge.

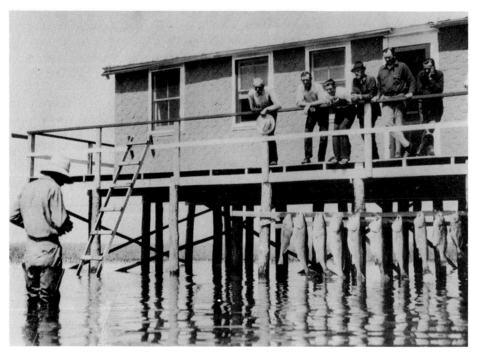

New Inlet fishing lodge, owned by George West, Sr., was built in 1925 and destroyed by the 1933 storm. Herbert West is the photographer, left, snapping a picture of fishermen with the day's catch of drum.

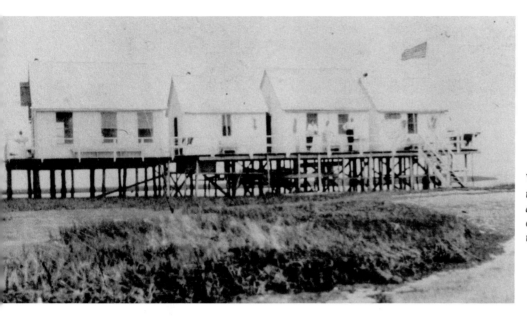

Walke Inn was built in the 1920s on the marsh at New Inlet and was owned by I. Walke Truxtun of Norfolk, Va.

New Inlet lodge in the late 1920s. Kemper Moore is on the deck of the lodge.

George West, Jr., sails his model sailboat in New Inlet near the lodge.

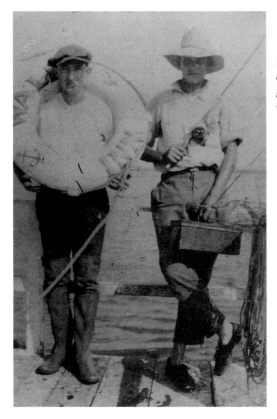

Herbert West, right, and an unidentified fishing partner pose on the deck of Walke Inn in the 1920s.

The Bon Homme Richard was used by Mr. and Mrs. George West, Sr., for oystering. On board in this photograph are, from left, Nancy Truxtun, George West, Jr., and Oliver Walke West.

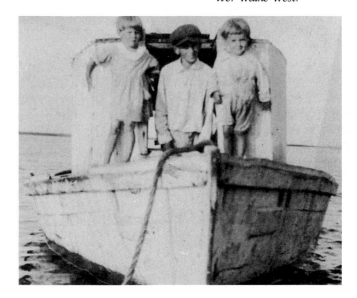

Walke Inn was destroyed by fire in 1928. These four workers are shown with the few furnishings salvaged from the blaze.

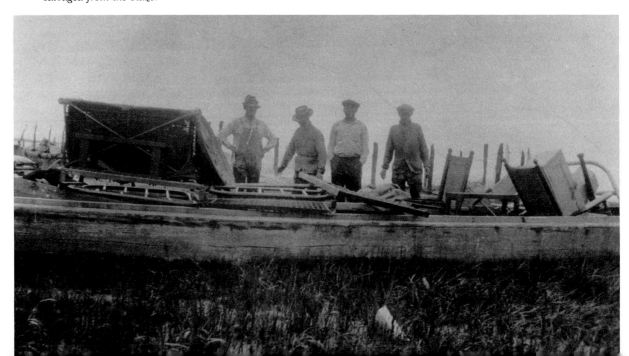

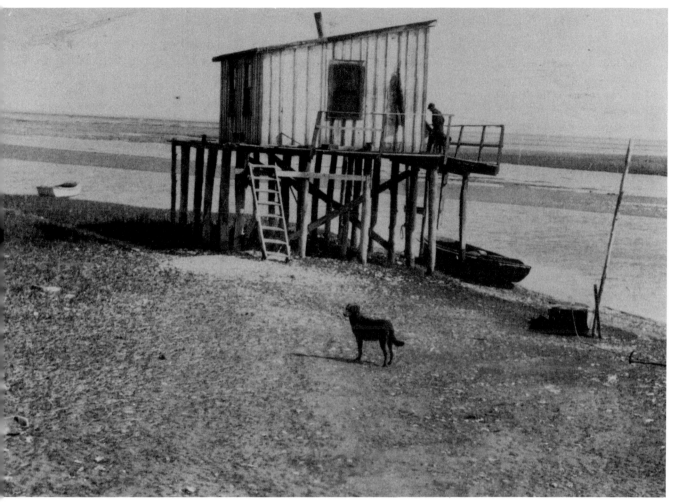

George West, Sr., owned this oyster watchhouse at New Inlet in the 1920s. The dog in the foreground, Big Boy, died in the fire in 1928 at the Walke Inn.

After a red drum fishing trip in 1939 at Cobb Island, George West, Jr., left, and Jim Taylor pose with the catch at the life-saving station.

The original Skidmore home on Skidmore Island. Isaac Skidmore helped salvage a ship on Smith Island and used the money to buy Long Point Island for $50 in 1852. He built two homes on the island between 1880 and 1890 and moved his family there. When Skidmore died, his widow sold the island to Charles Stevenson and Norris DeHaven. Stevenson and his wife lived on the island until the 1933 storm, which they survived by tying themselves to a flagpole. When the flood subsided, the Stevensons left for the mainland. George Skidmore bought the island in 1950, and Ed Skidmore White purchased it in 1965. The Nature Conservancy purchased the island in 1987.

The second Skidmore house built on Skidmore Island around 1900 for hunting parties.

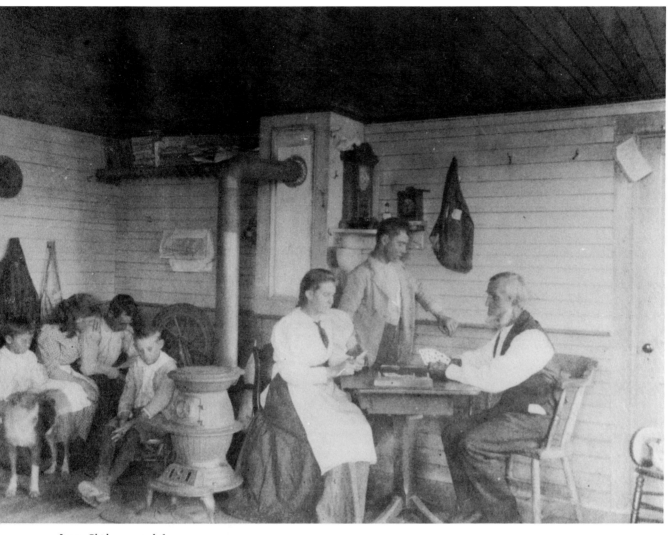

Isaac Skidmore and family at home on Skidmore Island, originally called Long Point Island. The picture was taken in 1883 or 1884. Pictured with Skidmore are his children Jake, Alice, Carmen, George, and Clay, and his wife Elizabeth. Skidmore Island is an inland island just north of Smith Island and east of the Eastern Shore National Wildlife Refuge near Cape Charles. It is owned by The Nature Conservancy.

Holly Bluff in 1933. This site is east of the Eastern Shore National Wildlife Refuge and overlooks Smith Island Bay. The property was cut off from the mainland in 1958 when the Intracoastal Waterway passed to the west.

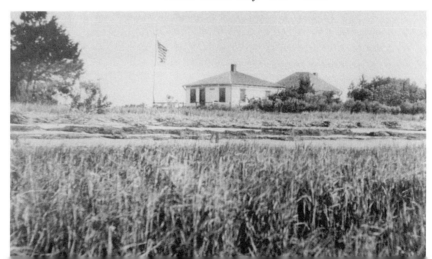

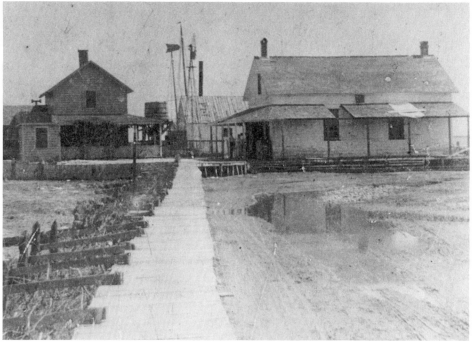

This is a clam pickling plant at Brighten's Landing in lower Northampton County in a picture probably taken in the 1880s. The plant was supposedly the first business in Northampton County to pay wages. In 1912 the business was purchased by Samuel Campbell, who began a family soup empire. Campbell shipped oysters from here, and each one was tagged with the label Ocean Cove Oysters. The landing was bought by the Cushmans in the early 1920s, and Mr. Cushman used it as an access point for his Mockhorn Island retreat. Brighten's Landing was a main seaport for lower Northampton County in the late 1800s and early 1900s.

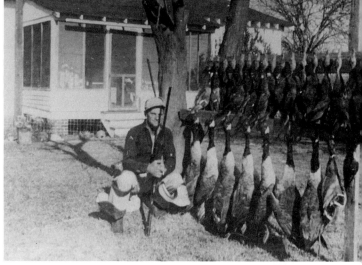

Charles Henry Matthews, Jr., with waterfowl.

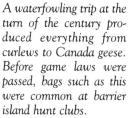

A waterfowling trip at the turn of the century produced everything from curlews to Canada geese. Before game laws were passed, bags such as this were common at barrier island hunt clubs.

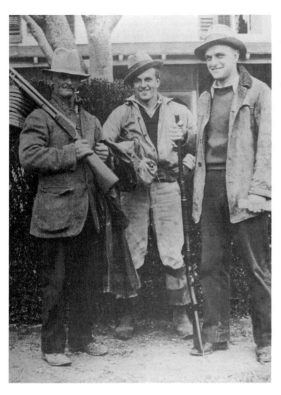

Ready to go hunting are, from left, Charles Henry Matthews, Sr., Charles Henry Matthews, Jr., and John Ketchum. The three were probably going shorebird hunting in the Smith Island area. Shorebird silhouette decoys are visible in the extreme left of the photo, just below Mr. Matthews' gun barrel.

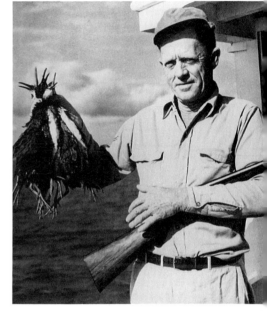

Milton Doughty displays a few marsh hens (clapper rail) for the camera.

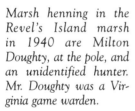

Marsh henning in the Revel's Island marsh in 1940 are Milton Doughty, at the pole, and an unidentified hunter. Mr. Doughty was a Virginia game warden.

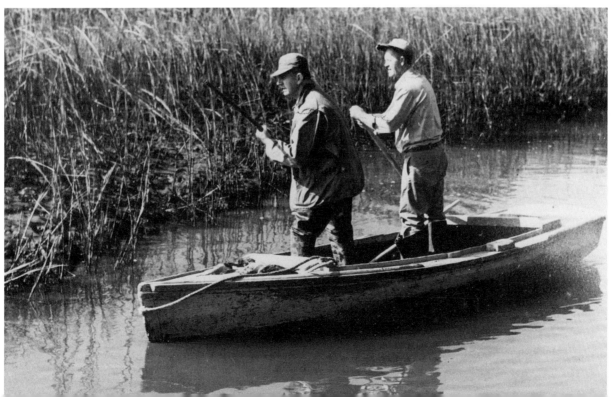

The original lodge, right, on Mockhorn Island built by Nathan Cobb, Jr., in 1852. The Cushman family of New York, later owners of the island, added on to the house. The building was used as part of the main club-house.

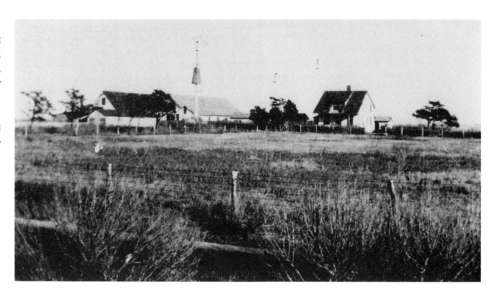

A marsh henning trip in the marshes behind Parra-more Island.

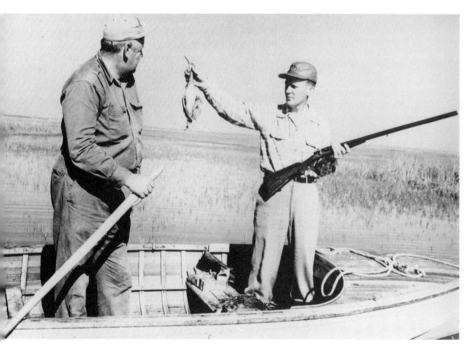

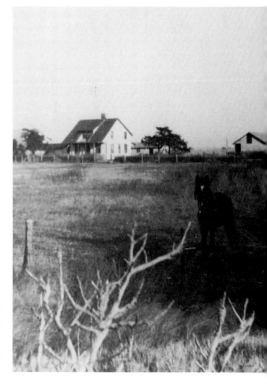

The 1852 lodge on Mockhorn Island built by Cobb. The Cushman family purchased the island in 1902 from Nathan Cobb, Jr.; they built barns and cooling houses, and added many amen- *ities. The Cushmans were in the bakery business in New York. Livestock was regularly kept on the island, and horses were used to pull carriages up and down the trails. Cushman built a* *concrete wall with floodgates to protect farmland and pasture from saltwater intrusion during high tides. Today Mockhorn is a state wildlife refuge and is located north of Smith Island.*

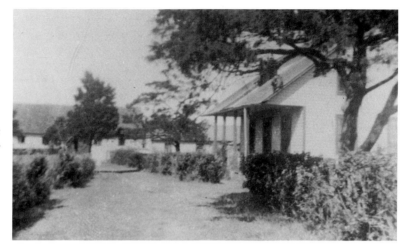

Part of the main house at Mockhorn, looking toward the stables.

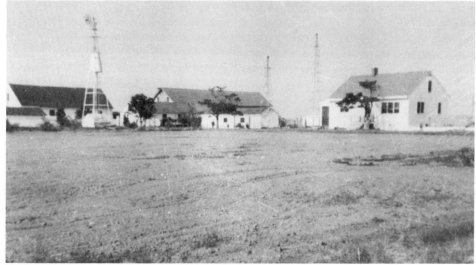

This house was built on Mockhorn by T.A.D. Jones, a government contractor. The building on the right was the residence of the caretakers, Mo and Lorraine Birch. The barn in the center of the photo was used for barn dances and parties for island guests.

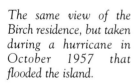

The same view of the Birch residence, but taken during a hurricane in October 1957 that flooded the island.

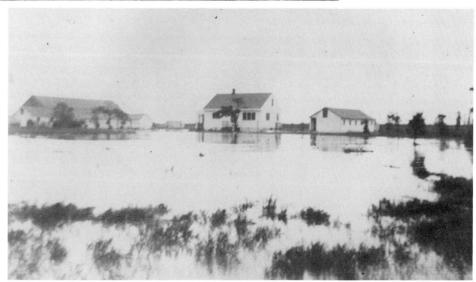

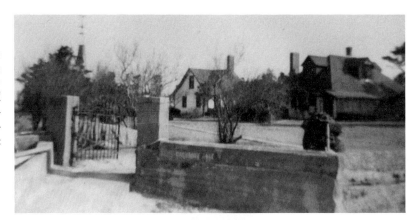

The original clubhouse is the small building at the left, which was begun by Nathan Cobb, Jr., and expanded by the Cushmans and Jones to include the large lodge at the right.

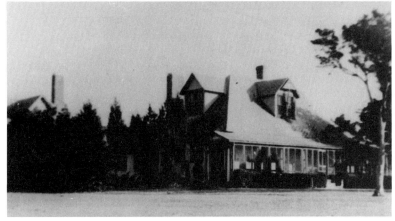

The Cushman lodge built on Mockhorn, a spacious, modern building with a huge porch. One of Mrs. Caroline Cushman's favorite pastimes was landscaping the island with flowering plants and scrubs not native to the Eastern Shore. After her husband died, she sold the island in 1948 to T.A.D. Jones.

The rear view of the main house on Mockhorn. In the foreground is a hotbed for raising vegetables and flowers.

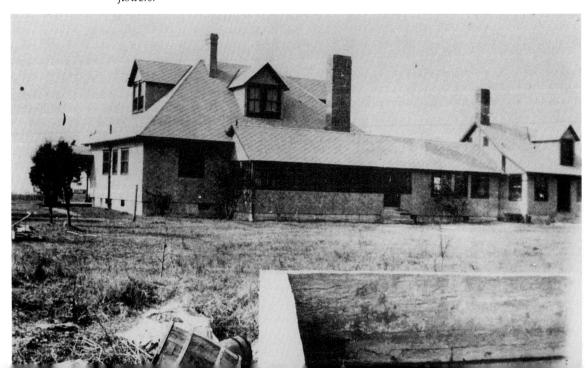

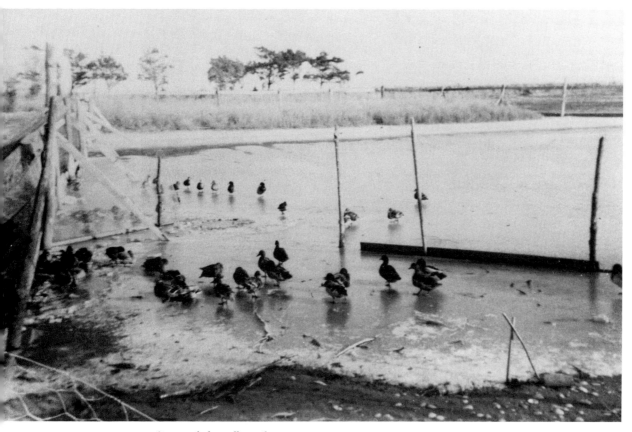

Some of the tollers (live decoys) used by the hunting guests at Mockhorn. The photo was taken in February 1958.

Front view from the water of the main lodge at Mockhorn during a hurricane in 1957.

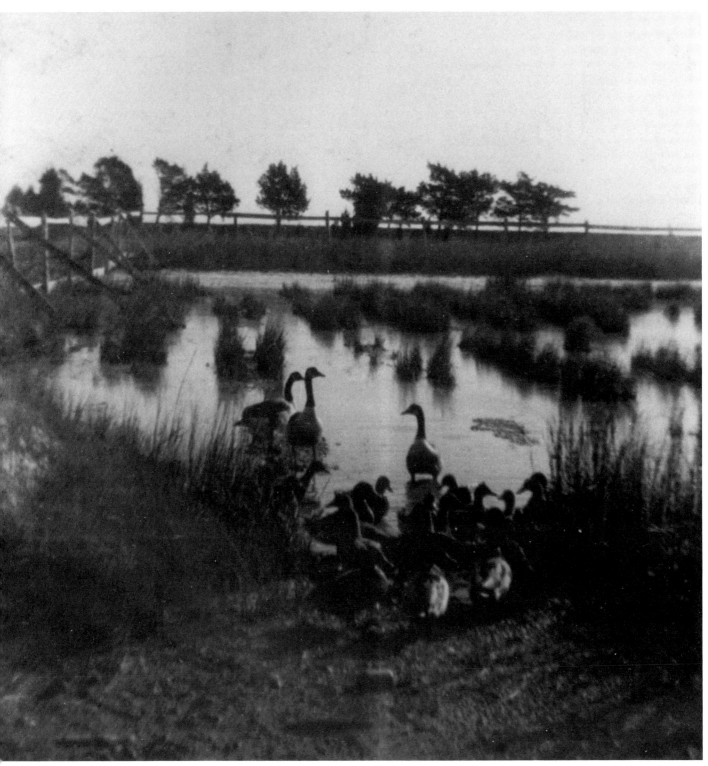

*Wild ducks and geese in a
compound at Mockhorn
in the 1950s.*

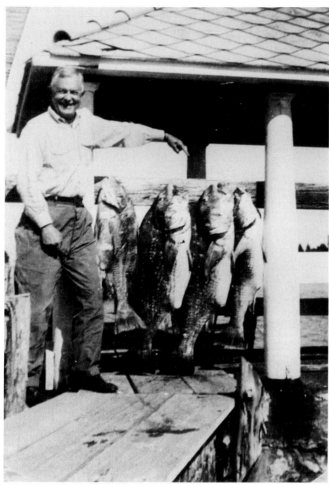

T.A.D. Jones, the owner of Mockhorn, with his catch of black drum at the Mockhorn dock. Jones, a contractor from New Haven, Connecticut, was the last private owner of the island before the state assumed ownership. Jones often entertained many high-ranking military officers and politicians at his island retreat, many of whom would fly in on helicopters for a few days of fishing or hunting. Jones died in 1959.

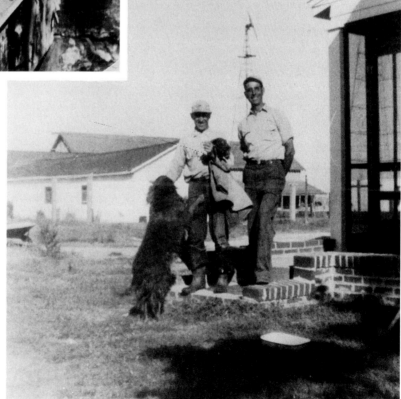

Moe Birch, left, and Major Richardson on Mockhorn, outside of the caretaker's cottage. Birch and Richardson were hunting guides and caretakers on the island.

This "duck" was used to transport hunters to their blinds at the Mockhorn lodge.

The windmill at Mockhorn was wrapped in ice during a winter storm in the 1950s.